POSTCARD HISTORY SERIES

Lower Merion
and Narberth

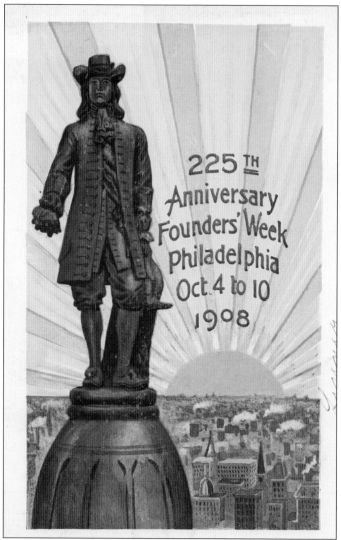

THE 225TH ANNIVERSARY FOUNDERS' WEEK, PHILADELPHIA, 1908. This postcard belongs to a series commemorating the 225th anniversary of the founding of Philadelphia by William Penn. For what may be the first time for a Philadelphia–wide event, the celebration focused on local history, rather than national or global events such as the 1876 centennial or the 1898 Peace Jubilee. The festivities included parades, fireworks, races, and a regatta on the Schuylkill River.

ON THE FRONT COVER: INDEPENDENCE DAY CELEBRATION, 1916. The Neighborhood Club of Bala Cynwyd's annual Fourth of July pageant was a time to celebrate. Here students are parading the grand old flag up Bryn Mawr Avenue, making a left onto Levering Mill Road on their way to the Cynwyd Elementary School. Community members gathered at the school for a patriotic program, athletic events, games, and prizes. (Courtesy of Lower Merion Historical Society.)

ON THE BACK COVER: MERION FIRE COMPANY NO. 1 AROUND 1907. This fire company, established in 1889, was the first one in Lower Merion Township. (Courtesy of Lower Merion Historical Society.)

POSTCARD HISTORY SERIES

Lower Merion and Narberth

The Lower Merion Historical Society

ARCADIA
PUBLISHING

Published by Arcadia Publishing
Charleston SC, Chicago IL, Portsmouth NH, San Francisco CA

Printed in the United States of America

Library of Congress Control Number: 2010921604

For all general information contact Arcadia Publishing at:
Telephone 843-853-2070
Fax 843-853-0044
E-mail sales@arcadiapublishing.com
For customer service and orders:
Toll-Free 1-888-313-2665

Visit us on the Internet at www.arcadiapublishing.com

CONTENTS

Acknowledgments 6

Introduction 7

1. Rivers, Roads, Railroads, and Trolleys 9

2. Inns, Restaurants, and Hotels 33

3. Mill Creek's Valley and Industries 43

4. Business Communities and Services 55

5. Schools and Libraries 75

6. Houses of Worship 95

7. Sports, Recreation, and Parks 103

8. Residences, Neighborhoods, and Streetscapes 119

ACKNOWLEDGMENTS

On the evening of October 24, 1949, about 90 community residents showed up for the first meeting of the historical society—three times more than were expected. Their vision was to fill the gaps left by other community organizations and the local school system, which did not teach the stories of their surroundings, the heritage left at their doorsteps. Over 60 years later, we have not only stayed true to our mission but have also expanded it to include stewardship, outreach, and active conservation—in some cases, even revitalization—of local landmarks and open spaces. With almost 400 members and dozens of dedicated volunteers, we have been able to continually change in order to meet the needs of the community, which is ever-evolving.

If an organization such as ours were a building, our members and volunteers would be the mortar holding it all together. This book is dedicated to them. Special thanks to Ted Goldsborough, past president and friend to many; the employees and caretakers of West Laurel Hill Cemetery, who have continually proved themselves to be wonderful neighbors and assets to the community; the staffs of Lower Merion School District and Lower Merion Township, who have partnered with us in innumerable projects over the years; and Max Buten, who was instrumental in the preparation of the images for publication.

—Jerry and Sarah Francis

Unless otherwise noted, all images appear courtesy of the Lower Merion Historical Society and the Francis family.

INTRODUCTION

A Pennsylvania Railroad marketing piece persuasively described Lower Merion as follows: "Its atmosphere is pure; it is thoroughly drained by numerous streams; its soil is fertile; and it is in a striking degree picturesque. Nature—the great landscape gardener—has carved and molded it into rolling hills and placid vales, and so studded it with trees and interlaced it with crystal rivulets that the picture everywhere is lovely to look upon." Yet, surprisingly, in distance and in time, much of Lower Merion is closer to center city Philadelphia than many Philadelphia neighborhoods. This favorable location has been a major factor in the growth of Lower Merion as a premier suburban residential area. Indeed, in many ways, the story of Lower Merion can be viewed as a microcosm in which the processes of the industrial revolution and suburbanization in America played out.

For many, Lower Merion evokes an image of the prestigious Main Line with its large estates and castles. But there was another side to Lower Merion—equally important were its factories, mills, and industrial facilities, which spurred innovation and economic development. For over 200 years, Lower Merion was one of the region's foremost agricultural and industrial powerhouses and produced everything from paper and textiles to railroad axles and lumber. This book focuses on the era of the most intense development, between 1900 and 1950, when the character of each neighborhood was coming into its own. Each chapter is organized according to geography: we start with the furthest east site and move west from one neighborhood to the next. We chose to focus on how the other 90 percent lived, so to speak, a history of the working class of the area—how they traveled, where they worked, what they did for fun, where they worshipped. It is easy for those of us lucky enough to live here now to forget about the simple histories of those who came before us, whose lives were spent traversing dirt roads, socializing at taverns, and filling their lungs with the soot expelled from railroad engines.

What many also don't know is that the Philadelphia Main Line is also one of the most culturally rich regions in the country. First settled in 1682 by William Penn's coterie of Welsh Quakers, the area has since undergone several transformations—from farmland, to industrial center, to home of some of Philadelphia's elite, to built-out suburb. Lower Merion and Narberth have been the set on which dramatic railroad rivalries were played out, while also witnessing the rise of the middle class.

There are many different kinds of history. We decided to develop this book as the history of the area and the history of the postcard, told in parallel. Before the advent of the telephone, postcards and letters were the main means of communication, and over time, used as souvenirs. In 1898, the U.S. Congress passed legislation to allow private firms to print cards, beginning the era of the private mailing card. Instead of government stamps on the front, photographs, engravings, and other images were used, giving them an added appeal. Up until 1907, it was not permitted by law to write anything but the address on the backs of these cards; personal messages had to be

scrawled across the artwork. As a result, these cards are referred to as "undivided backs," meaning they did not have a line going down the center of the back—a demarcation used later to separate the address from the personal message. Whether it has a divided back and where it was printed (until 1915, most postcards were still printed in Germany, whose printing methods were the best in the world) are two of the easier ways to date a postcard to a specific time period. The start of the century brought the first of the real photo postcards (postcards that were real photographs and printed on film stock paper), as well as the divided back, harkening the beginning of the so-called golden age of postcards. It is said that the publishing of printed postcards during this time period doubled every six months. Postcard collecting had become a national pastime.

In addition to the images, another intriguing piece of social history are the mundane, little snippets passed down from correspondents—the postcard messages. We have taken the liberty of incorporating some of the personal messages describing local landmarks and such found on the backs and fronts of our postcards. In their own squirrelly handwriting with misspellings, some were added as a last-minute annotation to the postcard image, others merely sending a well wish or a notice of comings and goings. It adds a fleeting connection to the buildings and people that no longer exist. And then there's our personal favorite: a small line, confined to the corner of a postcard of St. Mary's Episcopal Church—almost as though it was meant to be whispered in one's ear— unsigned, saying simply, "Yes, dear. I know I'm handsome."

The Lower Merion Historical Society is an all-volunteer organization dedicated to preserving the town's past for the future. For over 60 years, they have accomplished this by stewardship of local history, education of the community, preservation of historic resources, and outreach to promote awareness of the cultural heritage of the township of Lower Merion and the borough of Narberth. Society volunteers and partners are continuously striving to highlight history as a means of giving context to the occurrences of today. Although our claim to fame is our extensive atlas, burial records, and rare document collections, we are far more than just a library. The society's many accomplishments include preserving the mile markers that map the region's relationship with Philadelphia; the restoration of the 1812 Lower Merion Academy building, which is now in active use as the society's headquarters; and the compilation and publication of *The First 300: The Amazing and Rich History of Lower Merion*, a publication that is the reference book of choice for Lower Merion history. Current ongoing projects include the restoration of the original 1890 Cynwyd Train Station and the development of the Cynwyd Heritage Trail, a rail-to-trail that will reclaim an abandoned section of the Pennsylvania Railroad's Schuylkill Valley Division, as well as three industrial railroad bridges spanning the Schuylkill River.

One

RIVERS, ROADS, RAILROADS, AND TROLLEYS

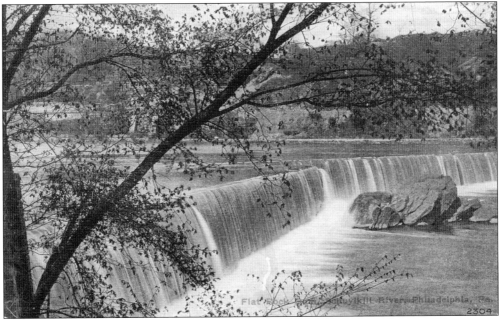

FLAT ROCK DAM, SCHUYLKILL RIVER. For the Lenape Indians and the early settlers, rivers were the main mode of transportation and the seminal reason for the settlement of the area. The Schuylkill River runs from west to east for the entire length of the township. Fisheries were located along the river where herring, bass, rockfish, pike, catfish, and shad were plentiful. Located in the vicinity of Mill Creek, Flat Rock Dam and the adjoining canal locks were built in 1818 for use by the Schuylkill Canal, a transportation corridor that moved anthracite coal and other goods on barges from the Reading area into Philadelphia. The dam brought the end to any fishing and also did away with the local fords that were used to traverse the Schuylkill River.

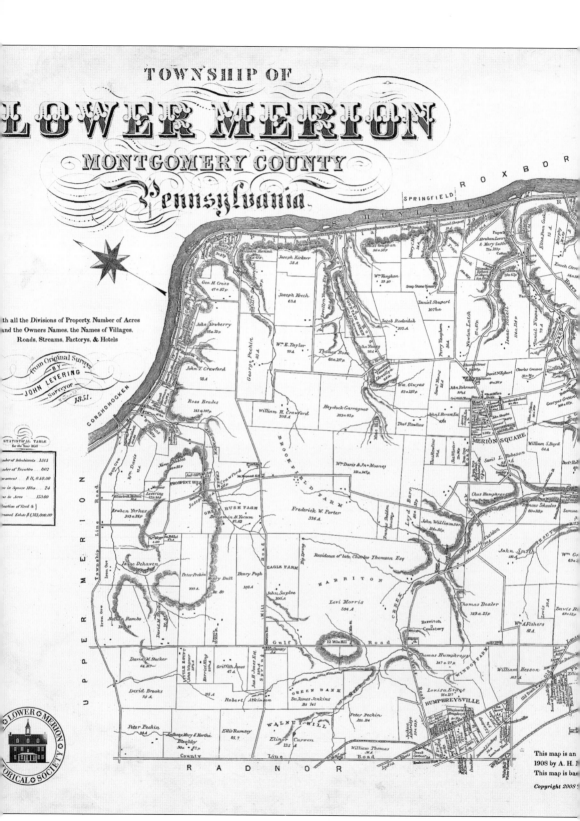

TOWNSHIP OF

LOWER MERION

MONTGOMERY COUNTY

Pennsylvania

th all the Divisions of Property, Number of Acres
and the Owners Names, the Names of Villages,
Roads, Streams, Factorys, & Hotels

from Original Survey
BY
JOHN LEVERING
Surveyor
1851

This map is an
1908 by A. H. M
This map is bas

Copyright 2008

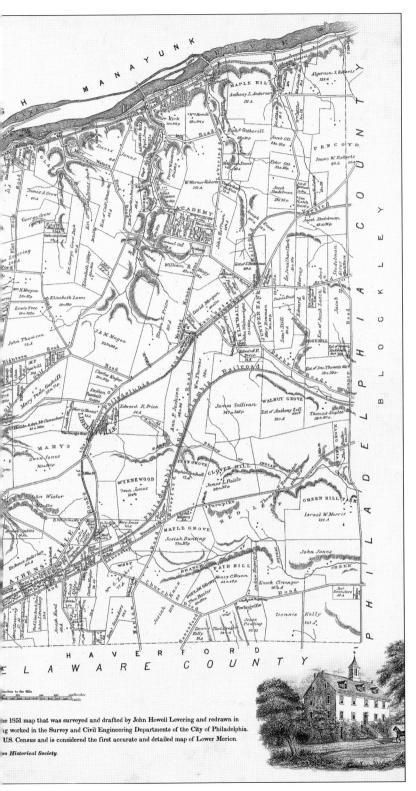

LEVERING MAP OF LOWER MERION, 1851. Pictured is an adaptation of the 1851 map that was surveyed and drafted by John Howell Levering and redrawn in 1908 by A. H. Mueller. The map reads: "Map of the Township of Lower Merion, Montgomery County, Pennsylvania. With all the divisions of property, the number of acres, and owners' names, the names of villages, roads, streams, factories, hotels & etc. And a plan of the Borough of Manayunk." It is considered the first accurate, detailed map of Lower Merion. At the time, Lower Merion was a farming community and dependent on water-powered mills; therefore, Levering took great care in documenting the location of the various water sources. In addition to the river and the streams, the springs and wells were identified.

11

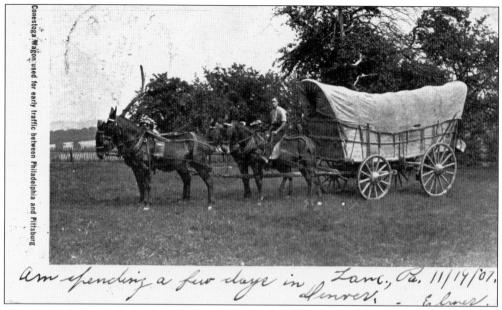

Am spending a few days in Lanc., Pa. 11/19/'07. Denver, — Elmer.

CONESTOGA WAGON. As Philadelphia continued to function as one of the nation's major seaports, roads were built in order to move goods west to Pittsburgh and beyond. Our local roads, now known as Montgomery and Lancaster Avenues, were used as major arteries for the transport of settlers and goods, mainly by Conestoga wagons. These were known as such because they were first manufactured in Conestoga, Pennsylvania. The person who wrote the handwritten message was moving west as well: "Am spending a few days in Denver, Elmer. Lanc., PA, 11/19/[19]07."

MONTGOMERY AVENUE, BRYN MAWR. Montgomery Avenue, because of its importance as one of the two major arteries in the areas, was the first road in the township to be macadamized and beautified. Tree-lined roads were indicative of the progressive transformation of the landscape from treeless farmland to a manicured suburb. On another note, this postcard exemplifies how mail was used as the main method of communication at the time. The personal message reads "Don't be so very much surprised if you receive a letter from me same day. Love to you. C. G. N. June 15, 1909." Postage cost 1¢, and there were two mail deliveries a day.

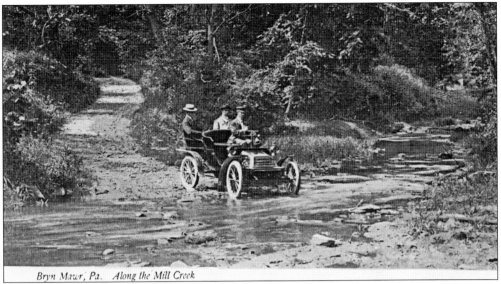

Bryn Mawr, Pa. Along the Mill Creek

ALONG THE MILL CREEK, BRYN MAWR. This is an image of one of the two fords still in use in Lower Merion. The car was made locally in Ardmore by The Autocar Company. It is traveling down Old Gulph Road, crossing Mill Creek where it intersects with Youngs Ford Road. At this location, near the entrance to the ford, is Milestone No. 10, a colonial-era roadway marker with William Penn's family's coat of arms carved in the granite.

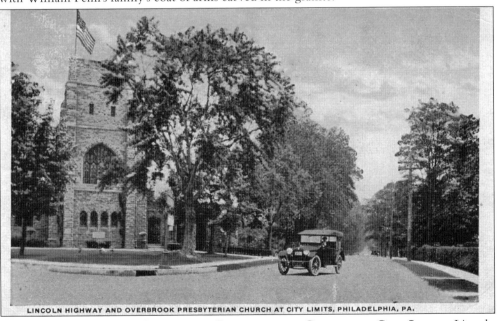

LINCOLN HIGHWAY AND OVERBROOK PRESBYTERIAN CHURCH AT CITY LIMITS, PHILADELPHIA, PA.

LINCOLN HIGHWAY AND OVERBROOK PRESBYTERIAN CHURCH AT CITY LIMITS. Lincoln Highway, or Lancaster Avenue (also known as U.S. Route 30), is one of the longest routes in the United States. The car depicted is directed towards the intersection of City Line Avenue and Lincoln Highway, which continues west the entire length of the township. Today it remains a busy intersection and an important link to Philadelphia. Additionally, the American flag flying at the top of the church's steeple was not in the original photograph—it was painted on, perhaps to make the church look more patriotic. This was a common practice for colorized postcards.

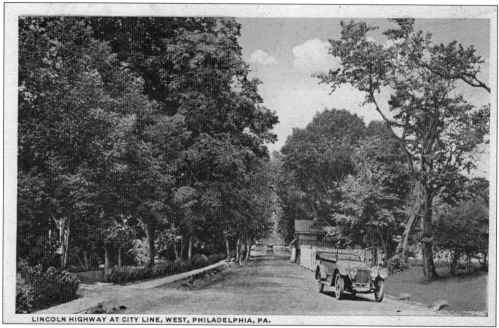

LINCOLN HIGHWAY AT CITY LINE, WEST, PHILADELPHIA, PA.

LINCOLN HIGHWAY AT CITY AVENUE. This is Lincoln Highway looking east towards Philadelphia. One can see a tollhouse on the right. Tollbooths were established along the township's main roads—a total of nine tollgates were along this route.

TOLLHOUSE AT LANCASTER AND CITY AVENUES. This is an early photograph of the busy tollhouse at Lancaster Avenue (also known as Lincoln Highway) and City Avenue. Built in 1871, it operated until 1917, at which time the Commonwealth of Pennsylvania took control of Lancaster and Montgomery Avenues and removed all local tollhouses. Pictured at the entryway is the caretaker; since collectors had to be on duty to collect tolls seven days a week, most tollhouses also functioned as family residences.

14

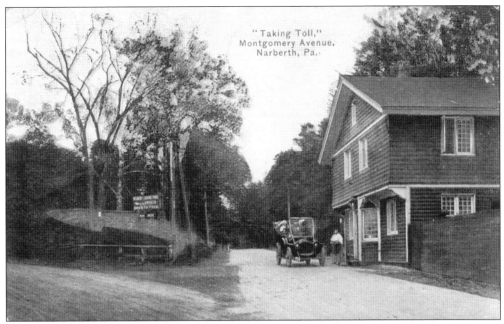

"**Taking Toll**." Both Lancaster and Montgomery Avenues were owned by the Philadelphia, Bala, and Bryn Mawr Turnpike Company. Pictured is the tollbooth at Montgomery Avenue and Meeting House Lane, across from the Merion Meeting House. The message reads: "Have a few cards for you already. The Kodak works fine. James Sadleir. June 7th."

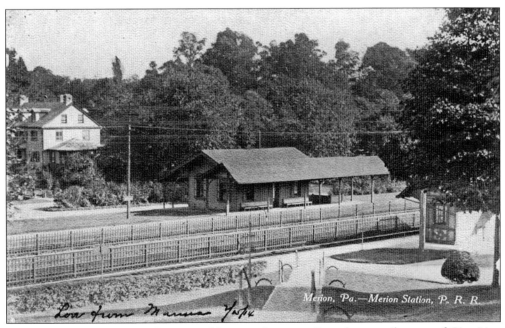

Pennsylvania Railroad Station, Merion Station. Less than a mile west of City Line Avenue, the first Pennsylvania Railroad (PRR) train station in Lower Merion is Merion Station. Made of brick and stucco, the surviving complex at Merion is one of the most complete examples of a typical, early-20th-century, suburban PRR station in the region.

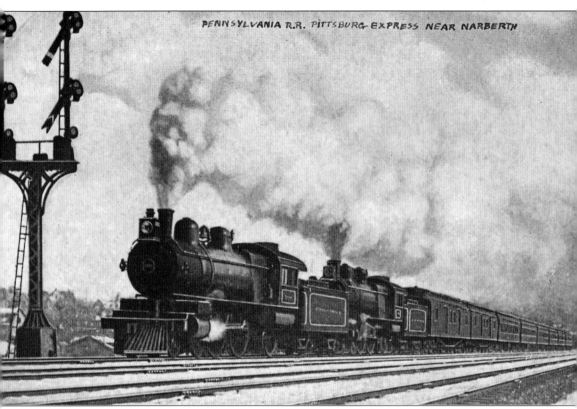

PENNSYLVANIA R.R. PITTSBURG EXPRESS NEAR NARBERTH

Pennsylvania Railroad: Pittsburg Express near Narberth. An important commuter and freight rail corridor, the PRR's Main Line, now known as the SEPTA R5, ran between Philadelphia and Pittsburgh. This steam train is traveling west from Merion Station and passing the signal tower on its approach to Narberth Station. This color image has a divided back and was published by the Locomotive Publishing Company in London.

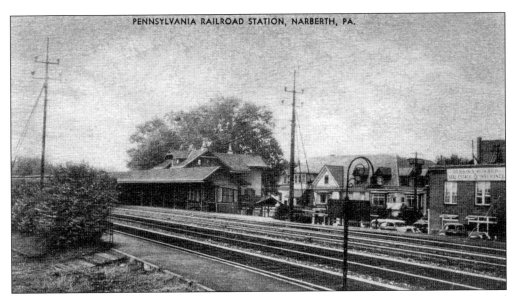

PENNSYLVANIA RAILROAD STATION, NARBERTH. Originally named Elm, the PRR renamed this station Narberth, meaning "sacred place" in Welsh, in an effort to gentrify the area. The Narberth station, located 7 miles from center city, was one of the PRR's stone-built Main Line structures dating to the 1870s. It predated the establishment of the borough of Narberth by over 20 years. The original stone structure was demolished in 1967. The personal message on the back reads: "We left home at 7 this morning and arrived at 1 o'clock traveled 100 miles it was a grand trip. We are going to Atlantic City on Monday some sports. Mrs. Watford. August 14, 1920."

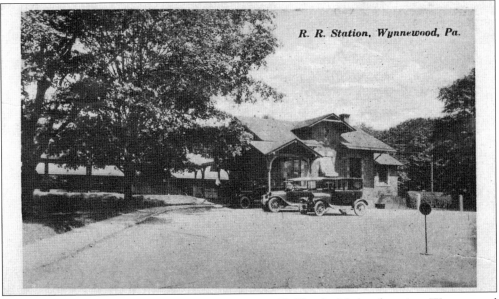

R. R. Station, Wynnewood, Pa.

PENNSYLVANIA RAILROAD STATION, WYNNEWOOD. Unlike the Narberth station, Wynnewood station still survives and is one of the best preserved stone stations built by the PRR along the Main Line. The message on this postcard reads: "Thursday. Mr. H goes to Cleveland this week – wish I was going along. I am wondering if your radio works o.k. it should for we liked it so much over here. Guess we will have ours going again – its together then its not. – VaLH. November 6, 1924."

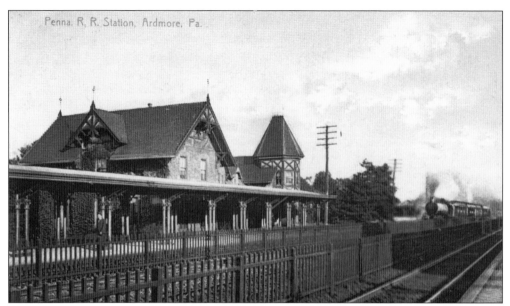

Penna. R. R. Station, Ardmore, Pa.

PENNSYLVANIA RAILROAD STATION, ARDMORE. This handsome station, constructed of native stone, was built in 1873 to serve the wealthy patrons of the PRR. By railroad standards, the trackside of the station (above) was considered the front and most important side. Thus, images such as this one (below) that depicted the back of the building, where commuters arrive and depart from the platform area, are rare. By 1957, the depot had fallen into disrepair and was demolished and replaced by a one-story masonry box with an open-area platform. Today the station is the focus of the Ardmore master plan, which aims to set the stage for the redevelopment and economic revitalization of the neighborhood. These colorized images have a divided back and were printed in Germany. The speeding train in the top image was painted in, as moving trains were too difficult to capture sharply using the photographic equipment of the time.

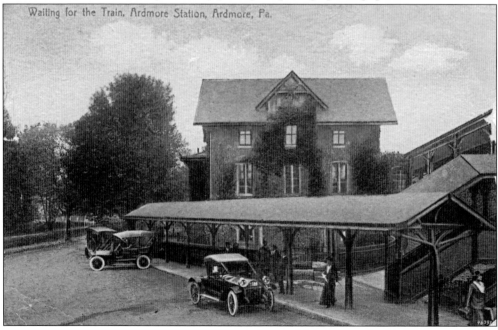

Waiting for the Train, Ardmore Station, Ardmore, Pa.

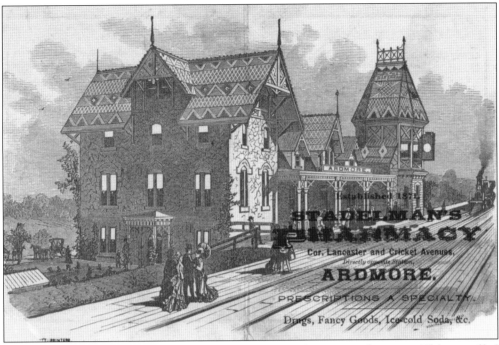

STADELMAN'S PHARMACY DIRECTLY OPPOSITE THE ARDMORE STATION. This so-called postcard was never meant to be mailed; rather, it had both sides printed with advertisements for local businesses. On one side (top image) is a lovely Victorian engraving of the Ardmore train station. The other side advertised events, goods, and businesses in close proximity to the station. By coupling them with pocket-sized train schedules, these cards also boasted an intrinsic practical value.

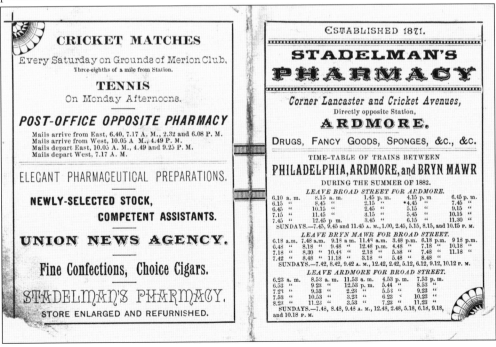

CRICKET MATCHES

Every Saturday on Grounds of Merion Club,
Three-eighths of a mile from Station.

TENNIS

On Monday Afternoons.

POST-OFFICE OPPOSITE PHARMACY

Mails arrive from East, 6.40, 7.17 A. M., 2.32 and 6.08 P. M.
Mails arrive from West, 10.05 A. M., 4.49 P. M.
Mails depart East, 10.05 A. M., 4.49 and 9.25 P. M.
Mails depart West, 7.17 A. M.

ELEGANT PHARMACEUTICAL PREPARATIONS.

NEWLY-SELECTED STOCK,

COMPETENT ASSISTANTS.

UNION NEWS AGENCY.

Fine Confections, Choice Cigars.

STADELMAN'S PHARMACY,
STORE ENLARGED AND REFURNISHED.

ESTABLISHED 1871.

STADELMAN'S

PHARMACY

Corner Lancaster and Cricket Avenues,
Directly opposite Station,

ARDMORE.

DRUGS, FANCY GOODS, SPONGES, &c., &c.

TIME-TABLE OF TRAINS BETWEEN

PHILADELPHIA, ARDMORE, and BRYN MAWR

DURING THE SUMMER OF 1882.

LEAVE BROAD STREET FOR ARDMORE.

6.10 a. m.	8.15 a. m.	1.45 p. m.	4.15 p. m	6.45 p. m.
6.15 "	8.45 "	2.15 "	*4.45 "	7.45 "
6.45 "	10.15 "	2.45 "	5.15 "	9.15 "
7.15 "	11.45 "	3.15 "	5.45 "	10.15 "
7.45 "	12.45 p. m.	3.45 "	6.15 "	11.30 "

SUNDAYS.—7.45, 9.45 and 11.45 A. M., 1.00, 2.45, 5.15, 8.15, and 10.15 P. M.

LEAVE BRYN MAWR FOR BROAD STREET.

6.18 a.m.	7.48 a.m.	9.18 a m.	11.48 a.m.	3.48 p.m.	6.18 p.m.	9 18 p.m.
6.48 "	8.18 "	9.48 "	12.48 p.m.	4.48 "	7.18 "	10.18 "
7.18 "	8.30 "	10.48 "	2.18 "	5.38 "	7.48 "	11.18 "
7.42 "	8.48 "	11.18 "	3.18 "	5.48 "	8.48 "	

SUNDAYS.—7.42, 8.42, 9.42 A. M., 12.42, 2.42, 5.12, 6.12, 9.12, 10.12 P. M.

LEAVE ARDMORE FOR BROAD STREET.

6.23 a. m.	8.53 a. m.	11.53 a. m.	4.53 p. m.	7.53 p. m.
6.53 "	9.23 "	12.53 p. m.	5.44 "	8.53 "
7.23 "	9.53 "	2.23 "	5.54 "	9.23 "
7.53 "	10.53 "	3.23 "	6.23 "	10.23 "
8.23 "	11.23 "	3.53 "	7.23 "	11.23 "

SUNDAYS.—7.48, 8.48, 9.48 A. M., 12.48, 2.48, 5.18, 6.18, 9.18, and 10.18 P. M.

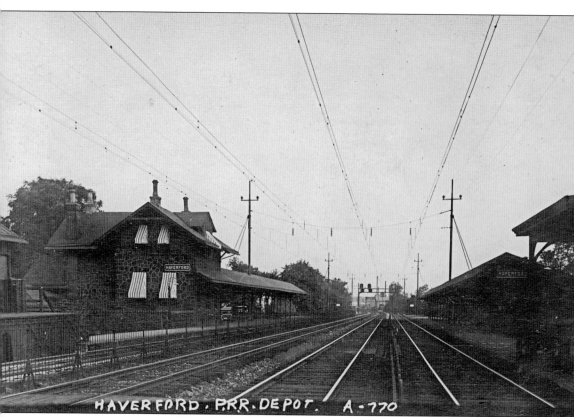

HAVERFORD · P.R.R. DEPOT. A-770

PENNSYLVANIA RAILROAD STATION, HAVERFORD. This image shows the second station to serve Haverford, around 1890, when the stop was still named Haverford College, after the nearby Quaker college. Also depicted are the striped awnings on the windows, which were standard accoutrement for many of the residential houses in the area.

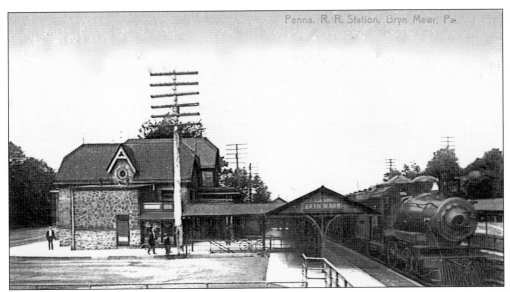

PENNSYLVANIA RAILROAD STATION, BRYN MAWR—TRACKSIDE. This station was the jewel of the PRR's crown of grand Main Line stations. The largest and busiest of the line's depots, the station at Bryn Mawr was built in the Victorian style. It was torn down in the 1960s and replaced by a plain brick structure. The postcard was printed in Germany. The personal message reads: "This is a large and inspiring station. Have just come in from a walk and am virtuously preparing to study. Love Dale K. October 13, 1908."

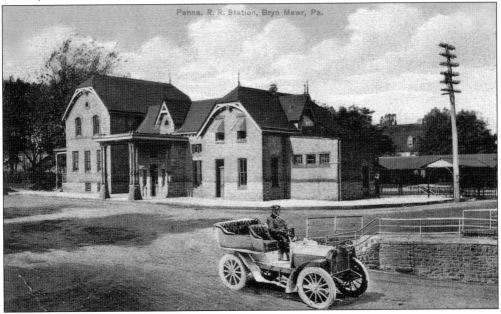

Penna. R. R. Station, Bryn Mawr, Pa.

PENNSYLVANIA RAILROAD STATION, BRYN MAWR—STREET SIDE. Shown is another rare depiction of a PRR station from the street side. Built in the late 1800s, this station served the only suburb that the PRR took a direct role in developing. Printed in Germany, the personal message reads: "Dearest Miss Mack. Thanks very much for your two nice card, you must be having a glorious time. We miss you very much. Mrs. Drexel is giving a party to-day and Tommy and I are going. Lovingly. Nancy. October 10, 1913."

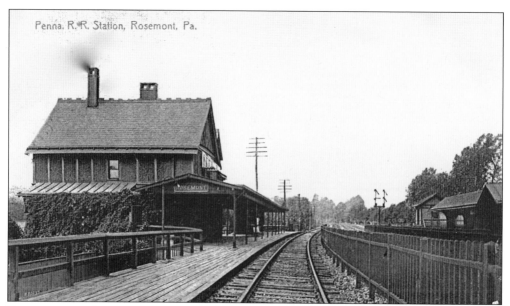

Penna. R.R. Station, Rosemont, Pa.

PENNSYLVANIA RAILROAD STATION, ROSEMONT. In 1863, Joshua Thomas donated land to the PRR for a passenger station to be named Rosemont, after his family estate. At the time, it was the farthest west stop in Lower Merion. Now known as Ashbridge, the property has the township as its steward and is enjoyed as a public park.

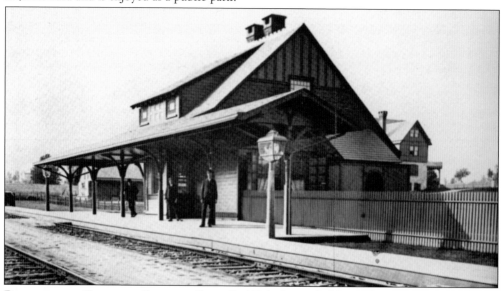

PENNSYLVANIA RAILROAD STATION, BALA. In 1884, the profitable PRR, which had the leading service to the Midwest, tried to cash in on the anthracite industry by building a Schuylkill Valley division that paralleled the Philadelphia and Reading Railroad into the coal regions of upstate Pennsylvania. The first station within the confines of Lower Merion on this division was Bala, which was constructed at that location mainly for the convenience of Pennsylvania Railroad president George Brooke Roberts, who lived in nearby Pencoyd. The station and surrounding area were named after a small village in Wales, from which Roberts's ancestors hailed. This neat frame structure was based on a standard design used by the railroad throughout its system. Until 1921, it also served as the local post office, with Mary A. Riddle as postmistress.

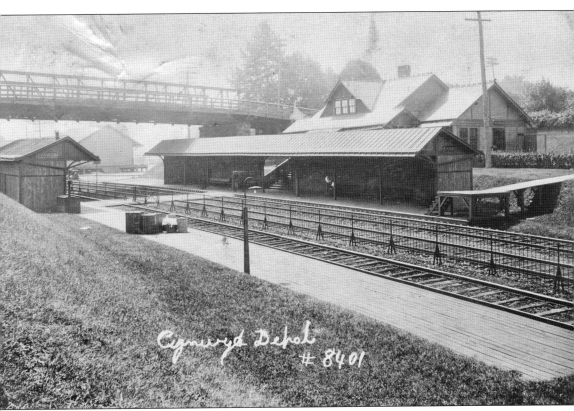

Cynwyd Depot
8401

PENNSYLVANIA RAILROAD STATION, CYNWYD—TRACKSIDE. In 1890, the Pennsylvania Railroad built and named their new station Cynwyd, also after a village in Wales. At the time, the nearby village was known as Academyville, but the name of the community quickly changed to match the name of the station. This was a typical PRR depot: it incorporated passenger, freight, and postal services. In addition to the passenger shelter shed, this image depicts a few pieces of baggage on the freight ramp that need to be loaded. The personal message reads: "There is a dandy tunnel up here. Emma. September 20, 1910."

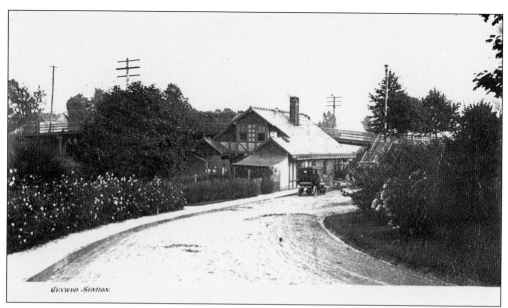

PENNSYLVANIA RAILROAD STATION, CYNWYD—STREET SIDE. The Adams Freight Company used these facilities, and they built a wooden frame addition on the station's west side in 1910. It also served as the local post office for the village of Cynwyd until 1921, with Emma Riddle, Mary's sister, as postmistress.

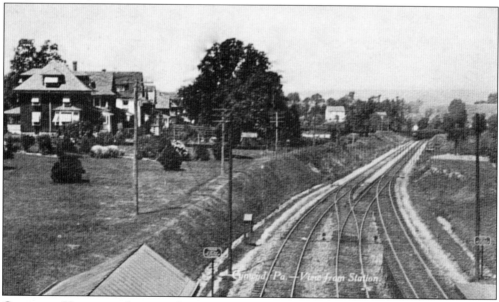

CYNWYD—VIEW FROM STATION. One can see a train approaching Cynwyd in the distance. Today the station is the terminus on a regional rail line to and from center city Philadelphia. Cynwyd Station is the only surviving original Schuylkill Division depot in the area and is currently undergoing a green renovation. It will serve as the main trailhead for the Cynwyd Heritage Trail, which will follow the abandoned section of the rail line. The personal message reads: "Dear William: Can you see the train in this picture? Aunt Lucy and Uncle Frank used to live 2 blocks from the Station and he went to Phila on the train to his office to fix peoples' teeth. Aunt Lucy sends love to you and everybody at home, so does, Grammies. Sunday Jan. 14, 1945."

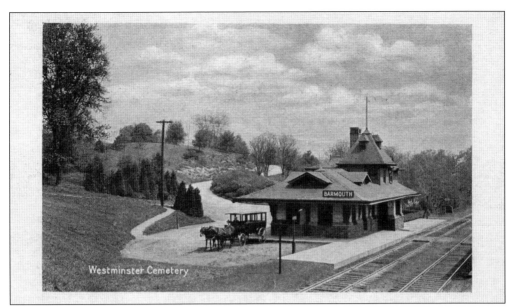

PENNSYLVANIA RAILROAD STATION, BARMOUTH. Barmouth Station was active from 1899 to 1986, after which the Southeastern Pennsylvania Transit Authority (SEPTA) decommissioned the tracks between Cynwyd and Ivy Ridge station, in Manayunk. Unlike Bala and Cynwyd, which were freight depots, Barmouth was a commuter station that also serviced funeral trains bearing caskets from Philadelphia to be laid to rest at either West Laurel Hill Cemetery or Westminster Cemetery.

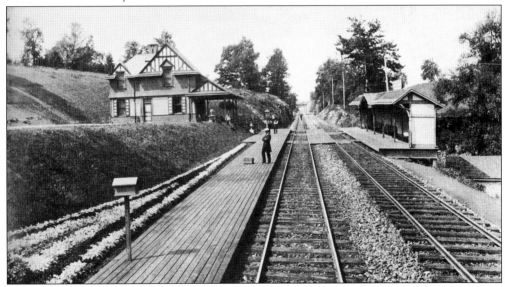

PENNSYLVANIA RAILROAD STATION, WEST LAUREL HILL STATION. Before the advent of parks, the only great swaths of green open space where the general public could go and picnic were inside cemeteries. Visiting cemeteries was a popular activity for Victorians. The West Laurel Hill Station, which operated from 1884 to 1899, was one of the most popular stops along the line and generated much weekend traffic. At the time, this area was considered to be country by city folk, and the railroad reinforced this notion by ornately landscaping the grounds around the platforms.

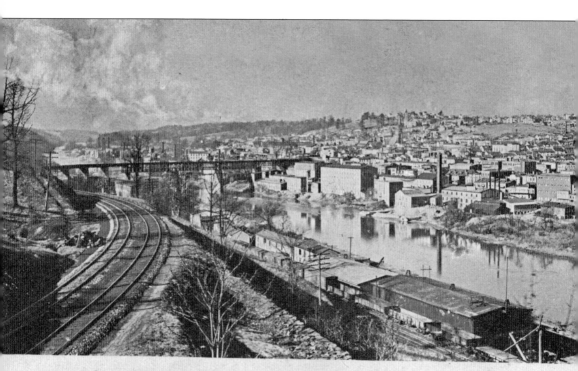

Philadelphia-Pennsylvania R.R. Bridge, Manayunk.

PHILADELPHIA–PENNSYLVANIA RAILROAD BRIDGE, MANAYUNK. Looking west toward the "S" bridge, this image depicts a panorama of Manayunk: West Manayunk, now known as Belmont Hills, is to the left side of the tracks, and Manayunk proper is to the right. Both sides of the river were lined with factories, mainly dealing with fabric, paper, and steel.

THE "S" BRIDGE AT MANAYUNK: DAY AND NIGHT SCENE. Here is an example of how postcard publishers made alterations to popular postcards. A full moon, clouds, illuminated windows, and reflections on the water were added to a daytime photograph of the "S" bridge to transform it into a night scene below. Constructed in 1884, the original PRR bridge, known as the "S" bridge, was a double-track, iron-truss bridge that connected West Manayunk (Lower Merion) to Manayunk (Philadelphia). Depicted in these images is a steam commuter locomotive moving toward Philadelphia, where the PRR tracks then run parallel to the Philadelphia and Reading Railroad tracks along the river. The line, from Philadelphia to Norristown, was electrified in 1930.

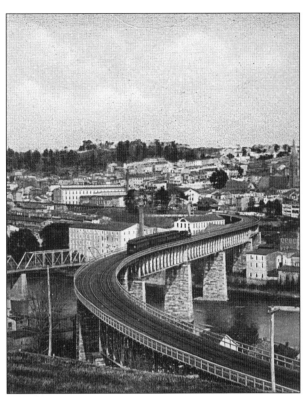

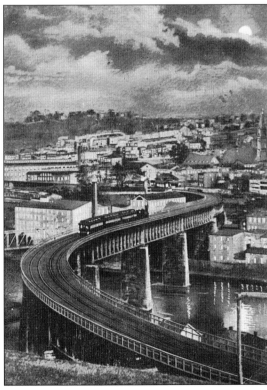

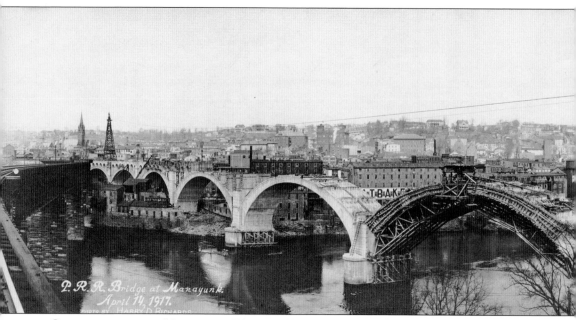

CONSTRUCTING THE MANAYUNK BRIDGE, 1917. Due to the increasingly heavy loads being transported by freight trains, by 1917, the "S" bridge was dismantled and replaced by the Manayunk

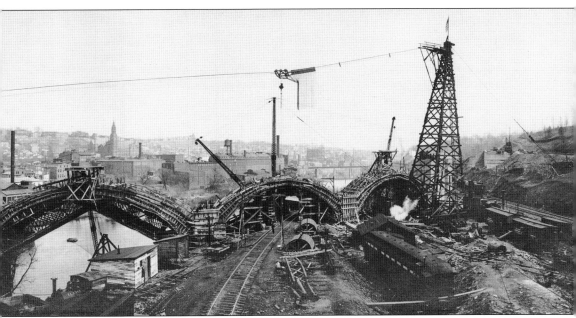

Bridge, a Spanish–arch concrete bridge. The Manayunk Bridge underwent structural work in 2000.
It is fondly regarded by generations of Philadelphians as the definitive icon of Manayunk.

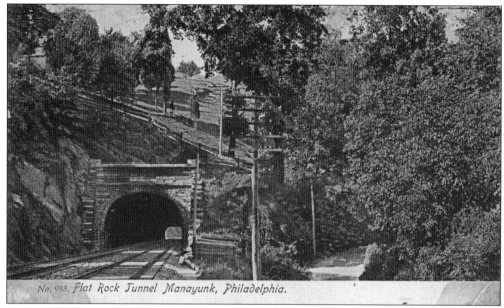

No. 988. Flat Rock Tunnel Manayunk, Philadelphia.

FLAT ROCK TUNNEL MANAYUNK, PHILADELPHIA. The Philadelphia and Reading Railroad follows the Schuylkill River the entire length of the township, a distance of 7.5 miles. Nearly a mile above West Manayunk is Flat Rock tunnel, which is 960 feet in length and cut through solid rock at a depth of 95 feet below the surface. The stations of this rail line in Lower Merion were Pencoyd, West Manayunk, Mill Creek (later changed to Rose Glen), and Spring Mill Heights. Today it is used for freight trains by the Norfolk Southern Railroad.

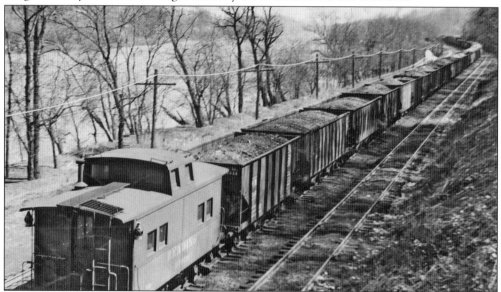

READING RAILROAD NEAR WAVERLY ROAD, GLADWYNE, AROUND 1946. Philadelphia and Reading Railroad traveled both sides of the Schuylkill River—this photograph was taken on the Lower Merion side. Interestingly there were few Reading Railroad stations on this line—it served the main purpose of transporting anthracite coal, or "black diamonds," from the mines of upstate Pennsylvania to the coal-hungry industries in and around Philadelphia—then known as the "Workshop of the World."

30

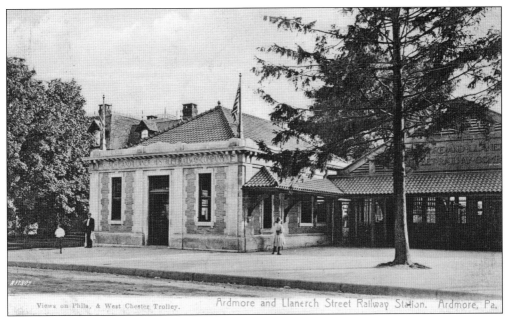

Views on Phila. & West Chester Trolley. Ardmore and Llanerch Street Railway Station. Ardmore, Pa.

ARDMORE AND LLANERCH STREET TERMINAL AND PHILADELPHIA SUBURBAN TRANSPORTATION COMPANY. The Ardmore trolleys ran from the Sixty-ninth Street terminal in Upper Darby to Lancaster Pike in the heart of Ardmore. Over time, a large, two-track terminal was constructed on the west side of the pike. The new terminal was described as one of the handsomest electric railway stations in the country when it opened in 1905, for it included an ornate fireplace, restrooms, separate waiting rooms for men and women, a newsstand, and a ticket office. The Philadelphia and West Chester Traction Company (below), also known as the P&W, changed its name in 1936 to Philadelphia Suburban Transportation Company, although most referred to it by the nickname "Red Arrow Lines." Buses replaced the trolleys in 1966. The personal message on the back of the above card reads: "We had a pleasant time at our Luncheon. Next Sat expect to visit Natural History. August 18."

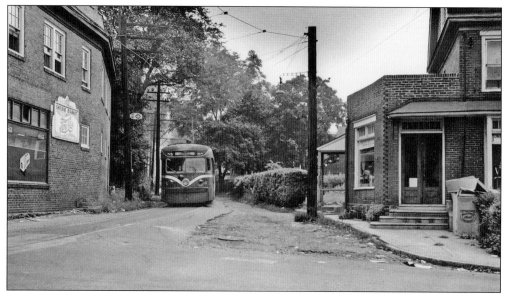

LIPPINCOTT AND EAST SPRING AVENUES, ARDMORE. Ardmore Trolleys, at some points on the line, actually went through a few backyards and alleys.

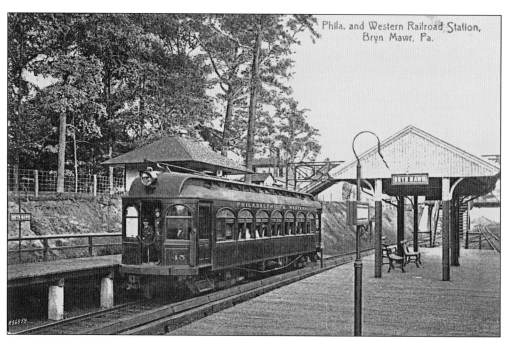

PHILADELPHIA AND WESTERN RAILROAD STATION, BRYN MAWR. In 1907, the P&W opened a high-speed electric line between the Sixty-ninth Street Terminal and Strafford. An extension to Norristown was added in 1912. Although only two P&W stations (County Line and Conshohocken Road) are within the township, the railroad skirts the township near Ardmore, Haverford, Bryn Mawr, and Rosemont, and many residents and students, who live or work in Lower Merion, use this commuter line.

Two

INNS, RESTAURANTS, AND HOTELS

BLACK HORSE TAVERN. "Entertainment for Man and Horse by W. Stadelman" read the original sign for the Black Horse Tavern. This inn stood at the entrance to Lower Merion at City Avenue and Old Lancaster Road. The site belonged to the Stadelman family well before the Revolutionary War. The tavern's infamy traces back to a skirmish in 1777, when American patriots attempted to prevent British forces from entering Lower Merion. Members of the Merion chapter of the Daughters of the American Revolution still possess a number of bullets that were plowed up from the fields surrounding the Black Horse. The tavern was razed in 1896.

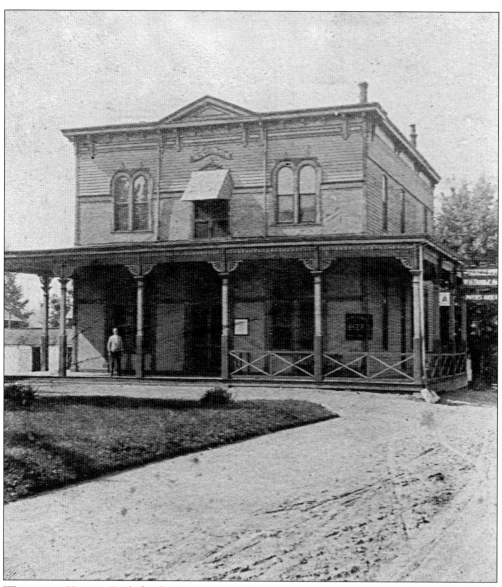

WISCONSIN HOUSE. Built for the Centennial and International Exhibition in 1876 as an exhibit house for the state of Wisconsin, this modest structure, described as "simple . . . not pretty, merely useful," originally stood several blocks behind Ohio House in Philadelphia's Fairmount Park. After the celebration, the house was auctioned off to the Simes family, who attempted to move the building to Lower Merion. Unfortunately the hauler broke down along the way, and the house was left in the middle of Conshohocken Road, near Belmont Avenue, where it obstructed traffic for over a year. Its final site was the intersection of Conshohocken State Road and Union Avenue, in Bala, where it functioned as a hotel for many years. Because of its proximity to the Belmont Driving Park, the Wisconsin House was well patronized by everyone from jockeys, breeders, and trainers to race enthusiasts. The establishment became so notorious that the surrounding neighborhood became known as Wisconsinville. Over time, it fell into disrepair and was demolished in 1961.

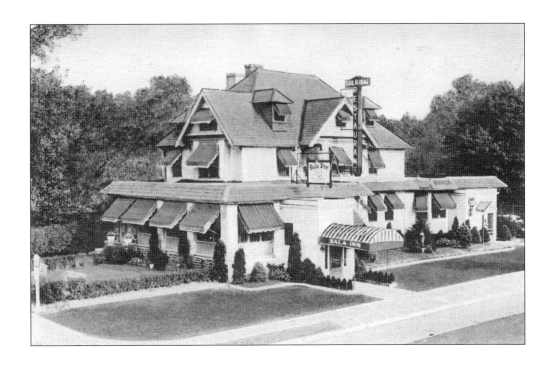

BALA INN, BALA. An example of a more contemporary wayside eatery, the Bala Inn, located along U.S. Route 1, catered to hungry travelers. The Seery brothers opened the establishment, which became famous for its checkered tablecloths, in the early 1930s.

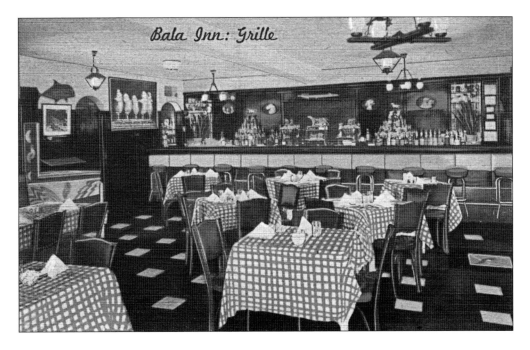

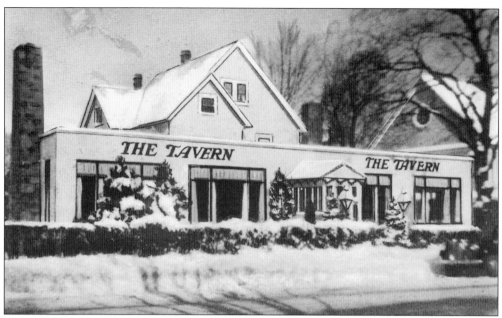

THE TAVERN, CYNWYD. Still a landmark eating establishment in the heart of Bala Cynwyd, the Tavern first built its reputation almost 80 years ago as a men's club and sports bar. The first owner, William Everhart, converted the first floor of his three-story home on Montgomery Avenue into a restaurant in the 1930s to cater to the travelers—basically an early 1900s version of a highway rest stop. Everhart was a big game hunter who decorated the establishment with his prized collections of antique guns and trophy animals, including bison, jaguar, and a bear. The main attraction, however, was the moose over the fireplace, which almost always had a lit cigarette in its mouth. While one can still get a plate of prime rib here, one has to cough up a little more than $1.35—the cost of the same entrée in 1941. Nick Zaravalas, the current owner, started at the Tavern as a waiter in 1965.

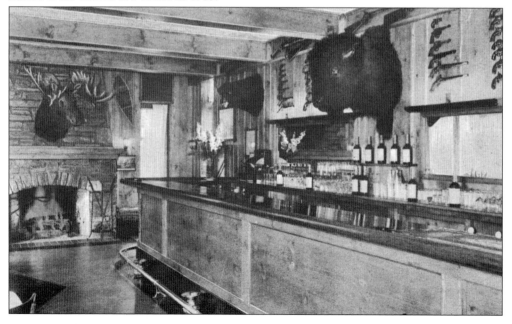

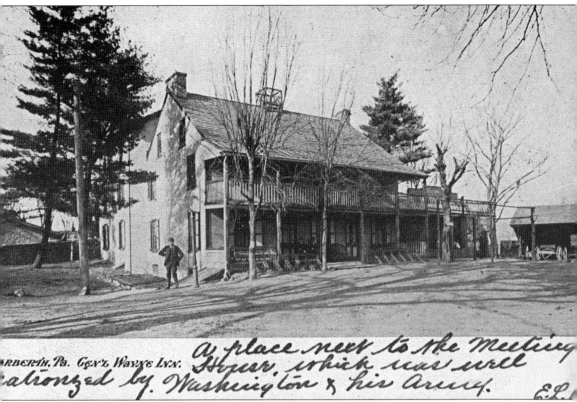

RBERTH, Pa. GEN'L WAYNE INN. *A place next to the Meeting House, which was well patronized by Washington & his Army. E.L.*

GENERAL WAYNE INN, MERION. Nestled next to Merion Friends' Meetinghouse, this tavern was established in 1704 and was in continuous use as an eating venue until 2000. For almost 300 years, it served a variety of functions, including as a gathering place for visitors, a post office, a passenger stop for travelers on stagecoaches, and, later, a stop on the Philadelphia and Columbia Railway. It was the foremost meeting place for township supervisors, where residents cast their votes in elections, and community leaders met to discuss the guiding principles around the establishment of the local public school system. The "Wayne" is also reputed to house the ghost of a colonial Hessian soldier, known fondly as Wilhelm, whose supposed presence proved good for business for the inn's numerous owners over the years. It has the double distinction of being listed on the National Register of Historic Places, and it is part of a local historic district. The personal message reads: "A place next to the [Merion] Meeting House which was well patronized by Washington and his Army. E. L. R. July 25, 1906."

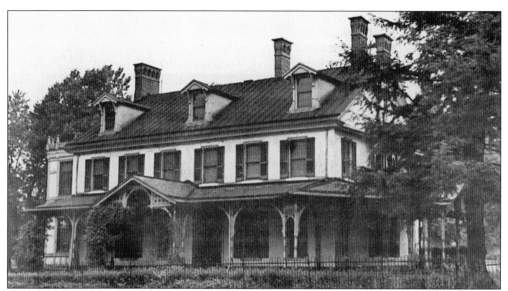

WILLIAM PENN INN, WYNNEWOOD. Because it was considered good luck to be located by a milestone, Lower Merion's Renaissance man Joseph Price built his William Penn Inn next to Milestone No. 6 along Lancaster Pike in 1799. The rooms in the inn were named for American heroes: Washington, Adams, Jefferson, and such; and the entrance hall, quirkily enough, was dubbed the "Nation." Each inn in the area catered to its own special market or clientele. While the General Wayne provided many amenities, including a full menu and an on-site blacksmith, thus, attracting a more prestigious customer, Price's patrons were mostly wagoners carrying goods to and from Philadelphia—the social equivalent of truck drivers today. The inn was repurposed as a condominium.

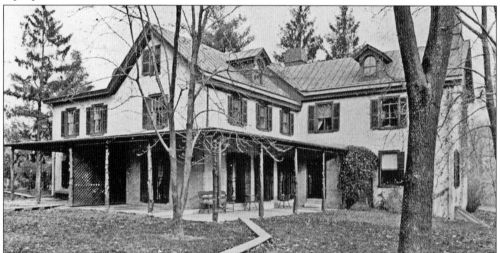

ST. GEORGE'S INN, ARDMORE. Originally known as the Three Tuns Tavern (a tun being a large cask or barrel, usually used for liquor), this inn came to the name of St. George's at the end of a cycle of different owners. By 1811, it was purchased by Dr. James Anderson to be used as a family residence. Considered one of the founding families of Ardmore, the Andersons remained in St. George's for the next 146 years. The dynasty was ended by the death of Dr. Joseph W. Anderson in 1957, at which point the family's 45-acre property was subdivided for construction of apartment buildings and the local YMCA.

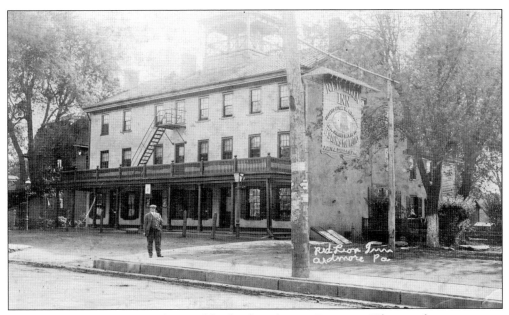

RED LION INN, ARDMORE. As stated in the first chapter, Lancaster Pike was the way west to the new frontier, and this popular highway had many inns to serve the travelers. Patrons and delivery carriages are pictured in front of this once-popular inn in Ardmore. The Red Lion was closed in the early 1920s, a victim of Prohibition and increasing congestion.

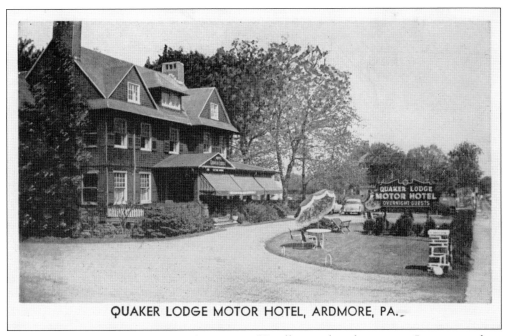

QUAKER LODGE MOTOR HOTEL, ARDMORE. "Small enough to know you. Large enough to serve you" was the motto of one of the first motor hotels in the area. Boasting of a "21-inch TV in every room," this hotel served a different, and much more transitory, clientele than the General Wayne Inn and the Haverford Hotel.

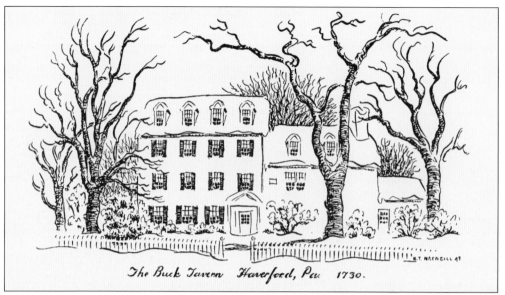

The Buck Tavern Haverford, Pa. 1730.

BUCK TAVERN, HAVERFORD. Constructed between 1730 and 1735, the Buck Tavern was a popular meeting place since it was situated in a prime location for travelers. Many innkeepers occupied this landmark building until its demolition in 1964. The postcard is an interesting specimen from a market for historic postcards that date from the 1950s. Although the tavern still existed at the time of the postcard's publication, the printers chose to depict it as an interpretive sketch, labeled "1730," perhaps insinuating how the property looked in its prime. This belongs to a postcard series of historic landmarks. The back description reads: "Stone structure with plaster facing. Popular inn and stage stop during the Revolution. Washington stopped here in September 1777, after the Battle of Brandywine. Appointed a post-tavern about 1832."

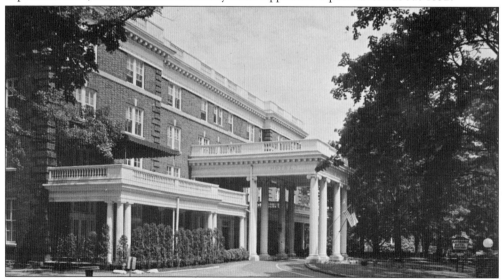

HAVERFORD HOTEL, HAVERFORD. "Situated by Philadelphia's most beautiful suburb," often referred to as "Main Line's Finest," reads the back of this postcard for this elite hotel, which hosted many a graduation party, wedding reception, and social event during its illustrious 60 years. President Eisenhower's granddaughter had her wedding reception here. Located on Montgomery Avenue and Grays Lane, it was only half a block away from the Merion Cricket Club.

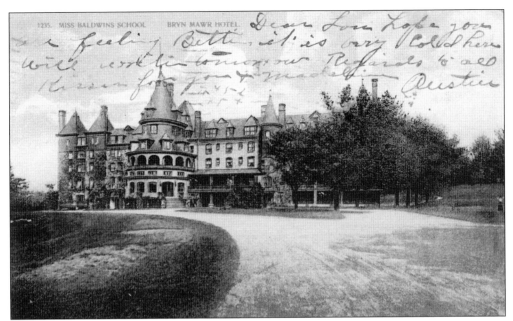

1235. MISS BALDWINS SCHOOL BRYN MAWR HOTEL

Dear Lou Hope you are feeling Better it is very Cold here will write tomorrow Regards to all Kisses for you + mother Austin

BRYN MAWR HOTEL, BRYN MAWR. Built by the Pennsylvania Railroad, this five-story, chateau-style structure was designed by the esteemed firm of Furness, Evans, and Company. The resort hotel provided a luxurious setting where the Philadelphia elite could summer in the country. In 1912, Florence Baldwin, founder of the Baldwin School, leased the hotel for the summer season and then later purchased it. This private, independent school for girls has operated at this site for almost 100 years. It is listed on the National Register of Historic Places.

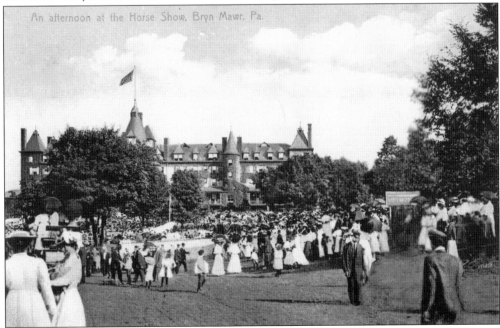

An afternoon at the Horse Show, Bryn Mawr, Pa.

AN AFTERNOON AT THE HORSE SHOW, BRYN MAWR. Lower Merion has many equestrian traditions, such as polo teams, horse shows, and hunt clubs. From 1896 to 1914, the Bryn Mawr Hotel hosted an annual horse show, which drew socialites from as far away as Boston.

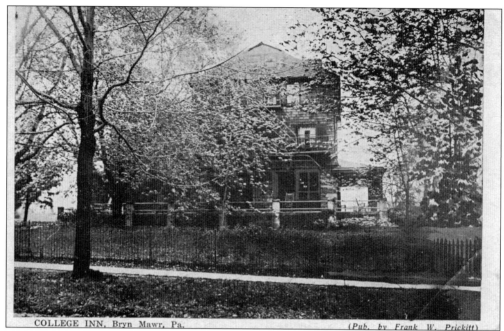

COLLEGE INN, Bryn Mawr, Pa. (Pub. by Frank W. Prickitt)

COLLEGE INN, BRYN MAWR. In 1901, famed architect Frank Furness designed this addition to the Bryn Mawr College campus. Resembling a Victorian home, the so-called College Inn was a small, gray-stone, two-and-a-half-story house that was wrapped with a shingled addition across the top and at each end. It was used as a guesthouse for visiting professors, students, and their families. Sadly, it was demolished in 1979.

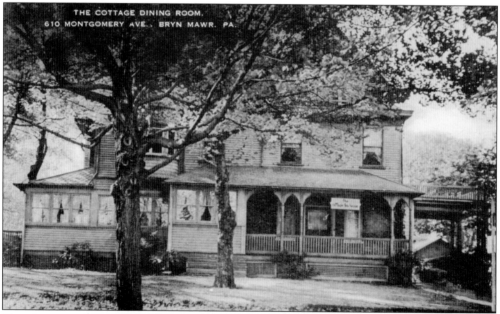

THE COTTAGE DINING ROOM, BRYN MAWR. With hotels, inns, private clubs, and a variety of recreational and sporting facilities, the Bryn Mawr area was the premier destination for many on the Main Line. A local landmark, "the Cottage" also served as a teahouse, that is, a Victorian restaurant or shop serving tea and a light afternoon meal.

Three

MILL CREEK'S VALLEY AND INDUSTRIES

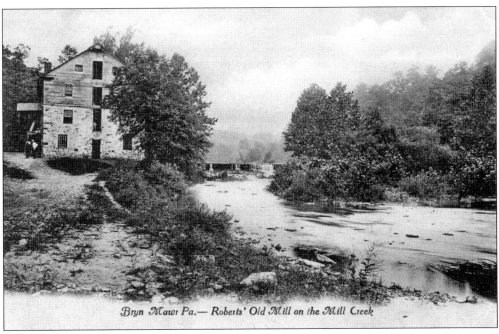

Bryn Mawr Pa.— Roberts' Old Mill on the Mill Creek

THE HARRITON/PYLE MILL, MISLABELED AS ROBERT'S OLD MILL, BRYN MAWR. Areas with sufficient clean water and sloping topography that produced rushing streams—conditions that were necessary to turn the waterwheels that powered the machinery in the mills—were the first to be settled and developed. Lower Merion's early settlers quickly realized the potential of Mill Creek as a perfect location for such mills. Before the Civil War and the advent of the steam era, many of Lower Merion's creeks hummed with the activity of over two dozen mills. Over its lifespan, the Harriton Mill was used as a grinding mill, a sawmill, and to produce plaster.

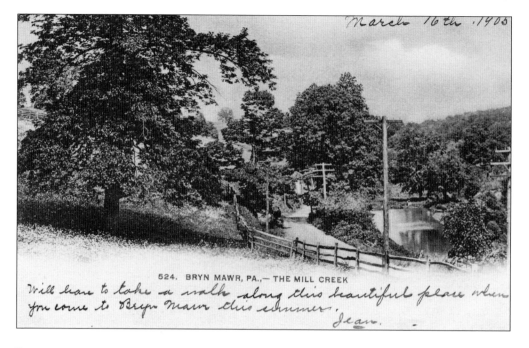

March 16th, 1905

524. BRYN MAWR, PA., — THE MILL CREEK

Will have to take a walk along this beautiful place when you come to Bryn Mawr this summer.
Jean.

BRYN MAWR, MILL CREEK. Itinerate photographers, whose creations were passed on to postcard publishers, were often unfamiliar with the region and the boundaries of neighborhoods. As a result, many postcards were wrongly labeled. Here we have two postcards of the same subject matter—yet one is labeled Bryn Mawr and one is labeled Ardmore. Most of the following Mill Creek scenes are actually in Gladwyne, but it was all too easy for these boundaries to become convoluted so far from the crisp zones of the business districts.

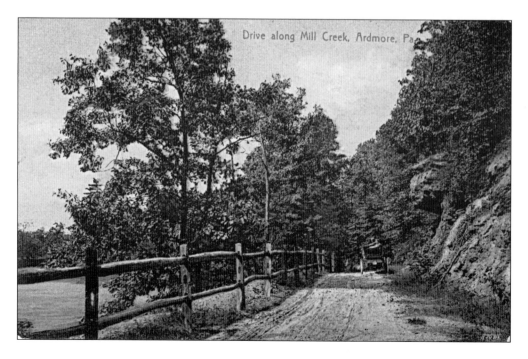

Drive along Mill Creek, Ardmore, Pa.

44

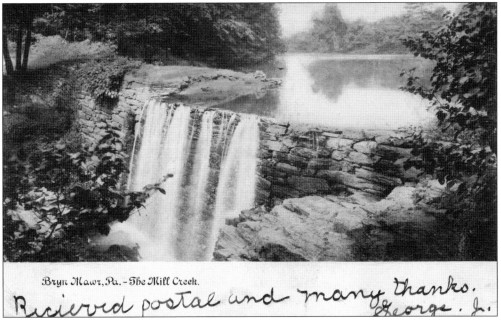

Bryn Mawr, Pa. - The Mill Creek.

Recieved postal and many thanks. George. Jr.

BRYN MAWR, MILL CREEK DAM. This dam is one of many up and down Mill Creek that were built to create millponds and to control water volume. This dam was constructed adjacent to Black Rock Road to create Dove Lake, which is near the open field identified as the Black Rocks, one of the more lovely spots in the township.

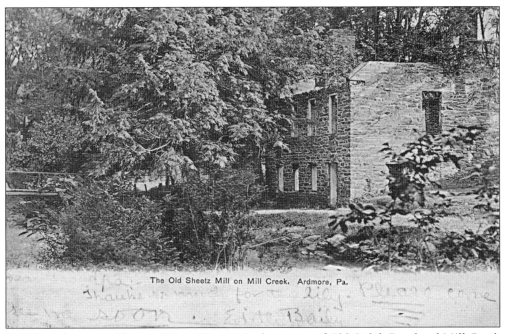

The Old Sheetz Mill on Mill Creek. Ardmore, Pa.

THE OLD SCHEETZ MILL ON MILL CREEK. At the corner of Old Gulph Road and Mill Creek stands the ruins of one of the longest-run mills in the region. For over 100 years, generations of the Scheetz family produced paper of various qualities. Today only remnants of the foundation walls mark its location.

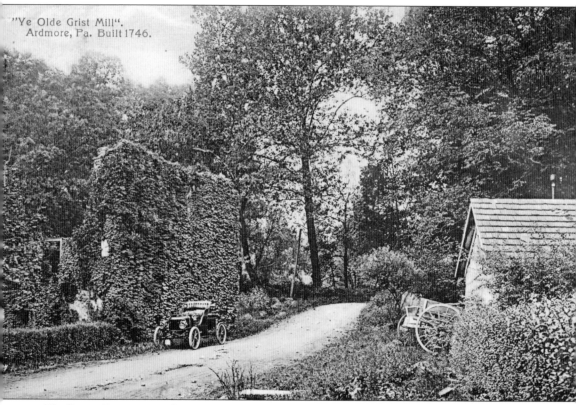

"Ye Olde Grist Mill".
Ardmore, Pa. Built 1746.

YE OLDE GRIST MILL, ARDMORE, BUILT 1746. Roberts is one of the most prominent family names in the history of Lower Merion. One of the first Europeans to settle in Pennsylvania, John Roberts arrived in Lower Merion in 1684 and quickly set up a gristmill on this site. Early settlers allegedly traveled miles to have Roberts transform their grain into flour. In 1746, sixty-two years later, Roberts's grandson John Roberts III built a new gristmill on the same site. The ruins of this structure still exist today along Old Gulph Road and include a 1746 date stone over a former doorway. The millrace that channeled water to the waterwheel and ran the mill still remains behind the foundation ruins.

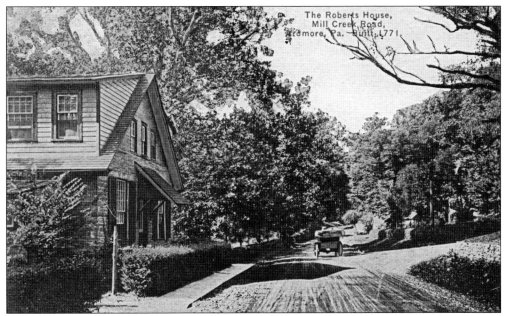

THE ROBERTS HOUSE, MILL CREEK ROAD, ARDMORE, BUILT 1771. Along this stretch of Mill Creek Road was John Roberts's Mill, which was comprised of a complex of structures and waterways. The house to the left was not actually the Roberts' house, as erroneously indicated by the postcard label, but rather was housing for the mill workers. Not pictured, but close by, is the real homestead of the Roberts family.

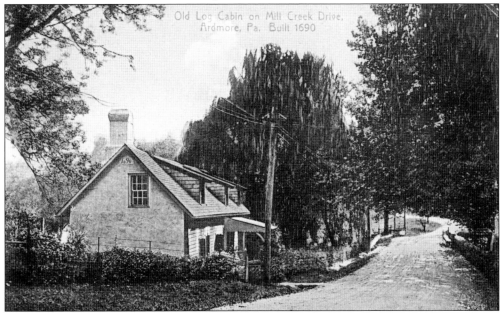

OLD LOG CABIN ON MILL CREEK DRIVE, ARDMORE, ERECTED 1690. Known as the "1690 House," this structure still stands at its original location at the corner of Mill Creek and Old Gulph Roads. It is believed that at least a portion of the building was the first residence of John Roberts. In later years, it was used as housing for the men who worked Roberts Mill. A 1690 date stone was added under the roof peak in 1900. Today it used as a single-family residence.

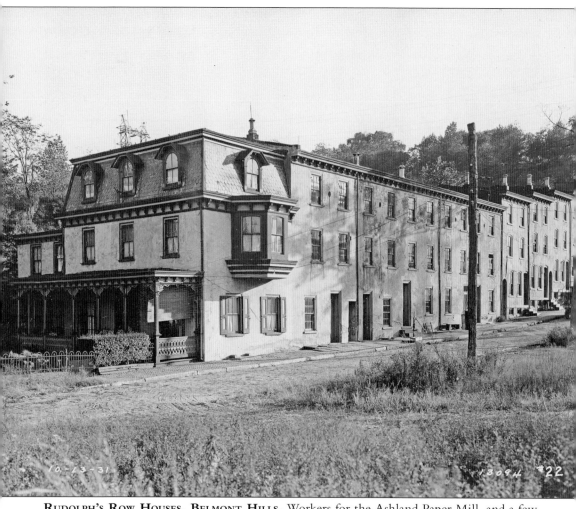

RUDOLPH'S ROW HOUSES, BELMONT HILLS. Workers for the Ashland Paper Mill, and a few from Pencoyd Iron Works, rented these row houses from Sebastian Rudolph. An open stretch between the houses and the Green Lane Bridge was often used for boxing matches, carnivals, and gypsy encampments. The majority of the workers complex was demolished in the 1950s during the construction of the Schuylkill Expressway.

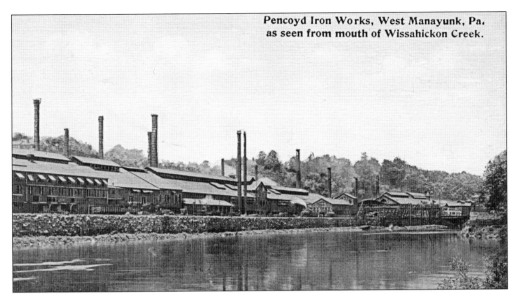

PENCOYD IRON WORKS, AS SEEN FROM MOUTH OF WISSAHICKON CREEK. Located along the west bank of the Schuylkill River, Pencoyd Iron Works had its genesis as a manufacturer of railroad axles. By 1859, the business expanded to include manufacturing iron and steel bridges. By 1883, its footprint encompassed 80 acres, including 2 miles of railroad tracks, and 35,000 tons of products were produced per year. There were over 700 employees, and the company owned between 50 and 60 dwellings that were used as workforce housing. In 1900, they merged with the American Bridge Company, then a major component of the United States Steel Corporation. The business was liquidated in 1944 after years of decline.

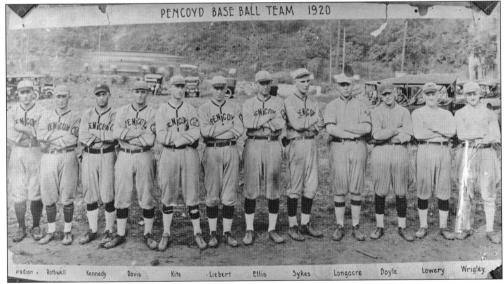

PENCOYD IRON WORKS BASEBALL TEAM, 1920. Some industries, including Pencoyd, were so large they had their own police departments, fire departments, and sports teams that operated completely separate from the municipal structure. Baseball was one of the many great recreational pastimes in the Lower Merion area. Teams were common, and the games drew large crowds. The Main Line League included such club teams as J and J Dobson, Autocar, Warwick, and R. G. Dun and Company. (Courtesy of John Kiker, Manayunk, PA.)

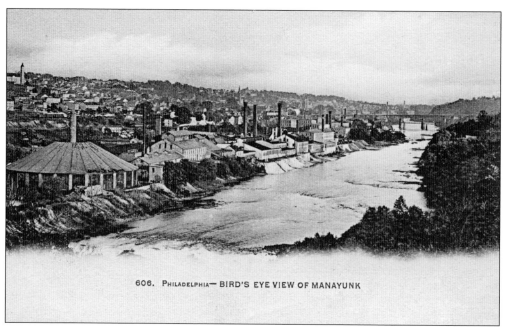

606. Philadelphia— BIRD'S EYE VIEW OF MANAYUNK

PHILADELPHIA—BIRD'S-EYE VIEW OF MANAYUNK. While the title infers that the focus of this photograph is the town of Manayunk, the central subject is actually the Schuylkill River. The river separated Manayunk from West Manayunk and was a superhighway for a variety of industries. Both towns were oriented around the riverfronts, because this waterway made prosperity and employment possible for the local residents.

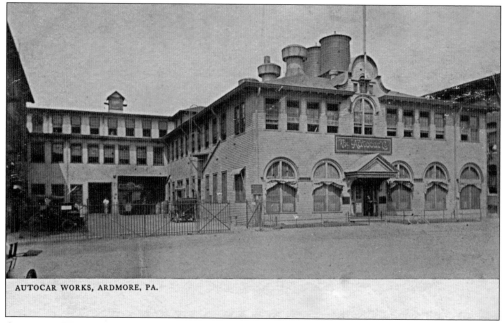

AUTOCAR WORKS, ARDMORE, PA.

AUTOCAR WORKS, ARDMORE. The crown jewel of Lower Merion's local industries was The Autocar Company. Founded in 1900 by brothers Louis and John Clarke, Autocar was one of the early pioneers in manufacturing cars and trucks. For more than 50 years, its factory was the center of activity in downtown Ardmore.

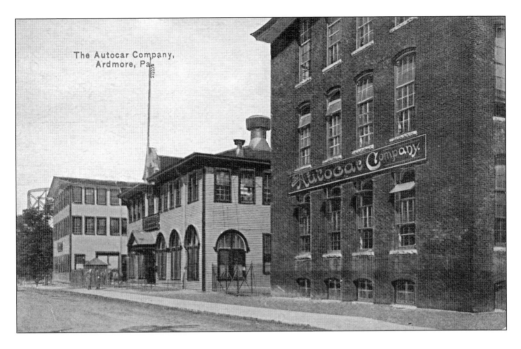

THE AUTOCAR COMPANY, ARDMORE. The factory complex was located along Lancaster and Greenfield Avenues and had more than 17 acres that were used to manufacture and assemble their trucks. The company employed thousands of men and women who assembled vehicles according to the customer's specifications, be they fire engines, coal trucks, moving vans, or school buses. The center building depicted in both postcards is the administration building. The personal message reads: "Everywhere you look there is nothing but Autocars. Some place this! Con. October 9, 1915."

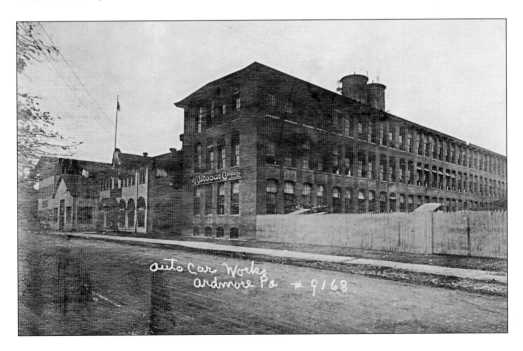

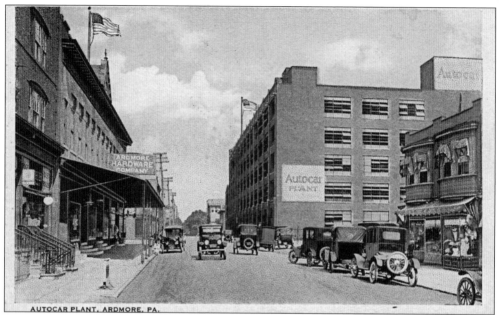

AUTOCAR PLANT, ARDMORE, PA.

AUTOCAR PLANT, ARDMORE. During the 1940s, the Ardmore Autocar factory built over 10,000 trucks and other military vehicles for the war effort. The plant closed in 1953, when White Motor Company bought Autocar and moved the plant to Exton. A dramatic fire of the complex occurred in 1956 during demolition by the Cleveland Wrecking Company. Autocar vehicles, now collector's items, are renowned for their simplicity, innovation, and durability.

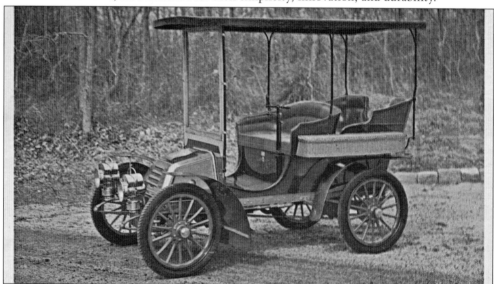

A 1903 AUTOCAR POSTCARD ADVERTISEMENT. This is a rare image of an Autocar passenger vehicle, which the company produced for only 10 years. The firm stopped building passenger cars after 1911 in order to focus on its growing truck business. Following are notes on the model from the Long Island Automotive Museum: "Rear Entrance Tonneau, Type 8. Price New: $1,700. Built by the oldest manufacturer of motor vehicles still in business in the United States, the Autocar was a quality-built light vehicle. . . . Top speed was about 25mph, but at that clip the Autocar—with its unusual steering handle—was difficult to control."

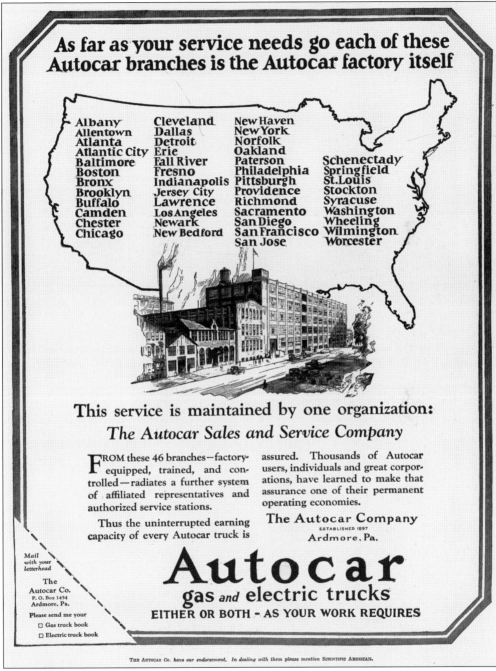

As far as your service needs go each of these Autocar branches is the Autocar factory itself

Albany	Cleveland	New Haven	
Allentown	Dallas	New York	
Atlanta	Detroit	Norfolk	
Atlantic City	Erie	Oakland	
Baltimore	Fall River	Paterson	Schenectady
Boston	Fresno	Philadelphia	Springfield
Bronx	Indianapolis	Pittsburgh	St. Louis
Brooklyn	Jersey City	Providence	Stockton
Buffalo	Lawrence	Richmond	Syracuse
Camden	Los Angeles	Sacramento	Washington
Chester	Newark	San Diego	Wheeling
Chicago	New Bedford	San Francisco	Wilmington
		San Jose	Worcester

This service is maintained by one organization:

The Autocar Sales and Service Company

FROM these 46 branches—factory-equipped, trained, and controlled—radiates a further system of affiliated representatives and authorized service stations.

Thus the uninterrupted earning capacity of every Autocar truck is assured. Thousands of Autocar users, individuals and great corporations, have learned to make that assurance one of their permanent operating economies.

The Autocar Company
ESTABLISHED 1897
Ardmore, Pa.

Mail with your letterhead

The Autocar Co.
P. O. Box 1454
Ardmore, Pa.

Please send me your
☐ Gas truck book
☐ Electric truck book

Autocar
gas *and* electric trucks
EITHER OR BOTH – AS YOUR WORK REQUIRES

AUTOCAR ADVERTISEMENT. The distribution and sale of Autocar products was not just a local enterprise, their specialized trucks had national appeal. Quality control and customer satisfaction were important to their business. Therefore, Autocar did not franchise the sales and distribution departments; every outlet and showroom was owned by the company, which guaranteed a connection with the customer and ensured product quality. From 1923 to 1927, Autocar even offered an electric vehicle, which had a top speed of 12 mph. The model was mainly used for delivery trucks in urban areas.

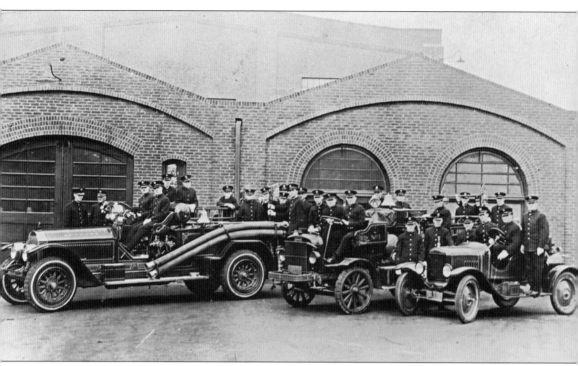

AUTOCAR FIRE COMPANY. The protection of property and the safety of the employees were always concerns, so Autocar, like many other heavy industrial complexes of its time, had their own fire department. However, since the Merion Fire Company was next door to the complex, Autocar retired their company soon after this photograph was taken.

Four

BUSINESS COMMUNITIES AND SERVICES

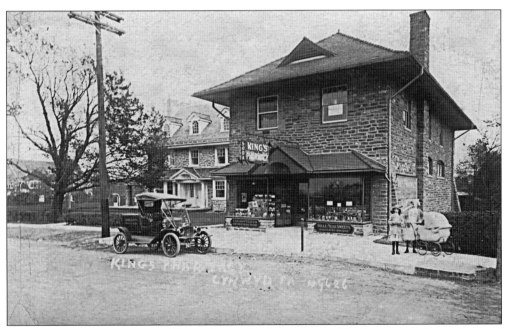

KING'S PHARMACY, CYNWYD. Like so many suburban communities, businesses clustered around their local train station, and Cynwyd was no exception. King's Pharmacy was located at 2 East Montgomery Avenue, in a small business district with a hardware store, a candy store, and the Egyptian movie theater. In addition to dispensing medicine, they had a large soda fountain, which was an attraction for the young and old. Another service they offered was book rentals at a rate of 2¢ per day. This is a black-and-white real photo postcard with a divided back.

SLAYMAKERS GROCERY STORE, BALA. Before the invention of supermarkets, people went to their corner grocery store, which sold mainly dry goods and seasonal items. Slaymakers was located at the corner of Bala and Union Avenues in Bala. The owners, as was typical of the time, lived in apartments above the store.

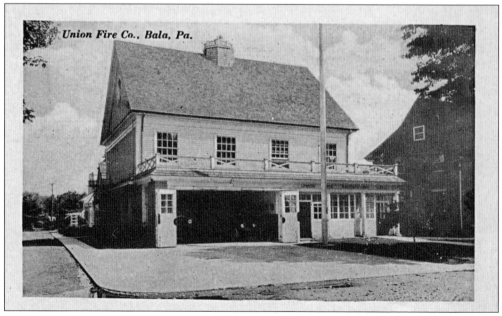

UNION FIRE COMPANY, CYNWYD. Construction of Cynwyd's new firehouse commenced in 1903. It is two stories high, with an engine room, club room, and parlor on the first floor. The second floor has a public hall that was used for a variety of community events, such as plays, parties, and turkey raffles. From 1914 to 1938, the firehouse took on the added responsibility of being the first public library in the neighborhood. It remains an active volunteer-run firehouse. This is a white-border postcard with a divided back.

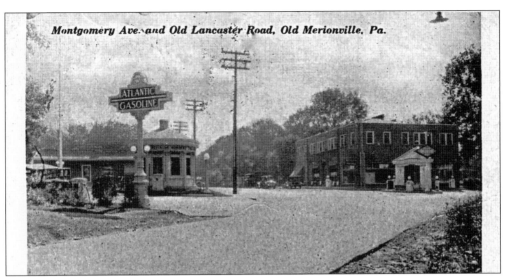

Montgomery Ave. and Old Lancaster Road, Old Merionville, Pa.

MONTGOMERY AVENUE AND OLD LANCASTER ROAD, OLD MERIONVILLE. With the introduction of the automobile, which was a luxury item that most could not afford, came the introduction of full-service gas stations. Some stations were actually quite beautiful, with ornate signs and lanterns. This gazebo-style station was located at the center of a roundabout in what is now Cynwyd. The personal message on the back reads: "Dear Elsie: Thanks for the nice letter but not for the news that you weren't coming down. Why didn't you keep that two dollars and come down? It's not too late yet. Took Mrs. Hartman into the City and had a wonderful time. Went to the Den of the Forty Thieves' again and heard some more news by the same lady. By all means buy the September Delineator. For you will be delighted with what you will find in it. See you soon, Freda. August 21, 1930."

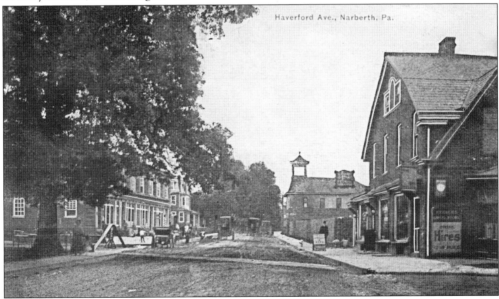

Haverford Ave., Narberth, Pa.

HAVERFORD AVENUE, NARBERTH. This image depicts the main street of Narberth around 1910. The peaked roof with the chimney is part of Davis's Store (later named Mapes's Store) on Haverford Avenue. Farther up the block was a firehouse with a cupola. Notice the wooden boardwalk spanning the width of the yet-to-be-paved avenue.

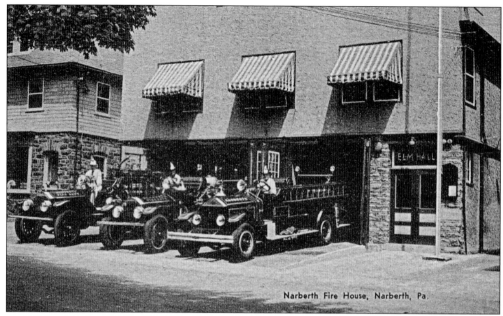

Narberth Fire House, Narberth, Pa.

NARBERTH FIRE HOUSE, NARBERTH. This image, taken about 1928, shows the c. 1907 firehouse at 107 Forrest Avenue, with American La France fire engines and a sign for Elm Hall (Elm refers to the neighborhood's original name, before being rechristened Narberth by the PRR). It was in Elm Hall that one applied for ration books during World War II and where borough council meetings were held. This structure was demolished when the municipal building was constructed on the site of former residences on Conway Avenue.

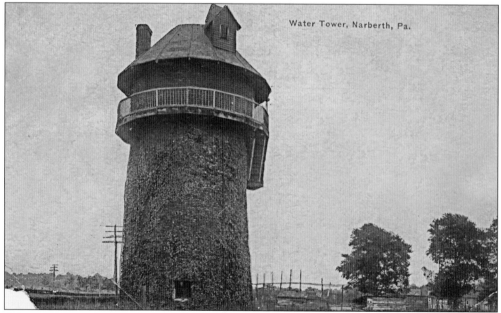

Water Tower, Narberth, Pa.

WATER TOWER, NARBERTH. Owned and operated by the Springfield Water Company, this water tower supplied water to the borough. It was located at the highest elevation in Narberth, on the south side of the Narberth Avenue bridge at the end of Elmwood Avenue. The postcard was photographed and published by Philip H. Moore of Philadelphia and dated 1913.

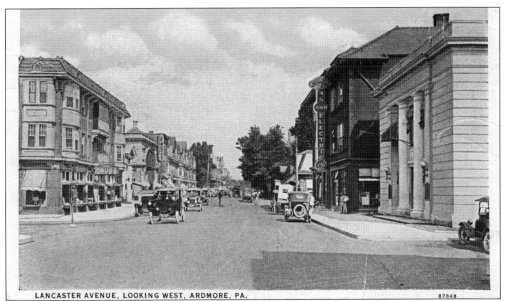

LANCASTER AVENUE, LOOKING WEST, ARDMORE, PA.

LANCASTER AVENUE, LOOKING WEST, ARDMORE. This is another view of Ardmore with the Autocar factory off in the distance. One can identify the storefronts of many service and retail businesses located along the main highway. The commercial district included the Merion Title and Trust and the ever-popular Palace Movie Theater. This is a colorized card with a divided back and a white border published by the Sabold–Herb Company, Philadelphia.

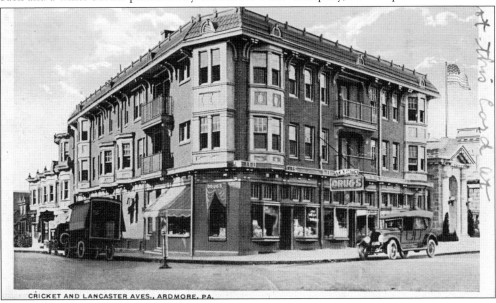

CRICKET AND LANCASTER AVES., ARDMORE, PA.

CRICKET AND LANCASTER AVENUES, ARDMORE. "Ardmore Has Everything" was the motto of the merchants along this commercial stretch of the Pike. The largest business district in Lower Merion, it contained a mix of small specialty shops, including a flower shop, a candy shop and tea room, a farmers market, a pharmacy, two movie theaters, banks, and dress shops. At the time, other village business districts only constituted a few shops along one block. This main street was recently designated the Ardmore Historic District by the township. The personal message reads: "This is the picture of the drug store I got this card at. Ettie. October 9, 1923."

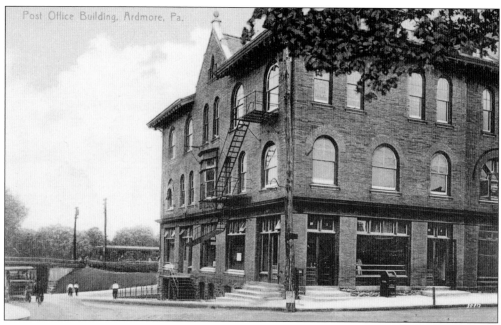

Post Office Building, Ardmore, Pa.

MERION TITLE AND TRUST BUILDING, ARDMORE. Because of its proximity to the Ardmore train station, this structure housed the local post office. The upper floors were used as offices.

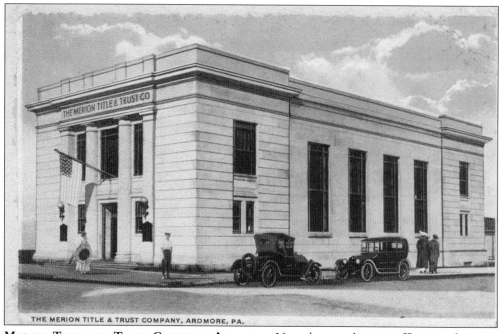

THE MERION TITLE & TRUST COMPANY, ARDMORE, PA.

MERION TITLE AND TRUST COMPANY, ARDMORE. Next door to the post office was the main branch of the Merion Title and Trust Company, one of the three large banks along the main street of Ardmore.

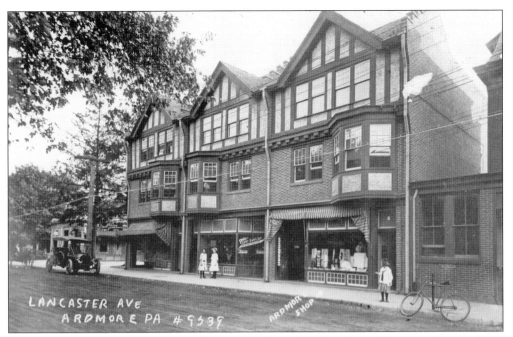

LANCASTER AVENUE, ARDMORE. This image from 1917 is of Retail Row with mixed-use construction: the shops operated out of the first floor, while apartments occupied the upper floors. On the far left side, one can see the Ardmore trolley station. While these buildings still exist today, the facades have changed so dramatically that they are recognizable only by the roof profiles.

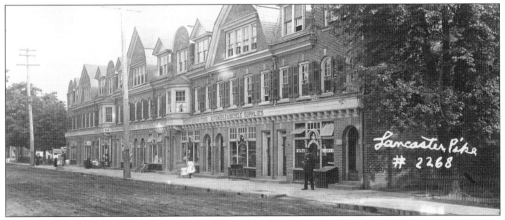

LANCASTER PIKE, ARDMORE. Here is another view of Lancaster Avenue one block west of the above perspective. Note the consistency of the quality and style of the architecture.

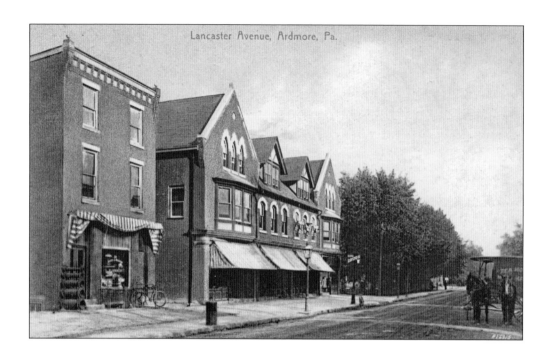

Lancaster Avenue, Ardmore, Pa.

BEFORE AND AFTER: BUSINESS SECTION, ARDMORE. The above image shows a section of Lancaster around 1910. Below is the same section around 1940, showing a much more built-out, intense commercial use. The green space has been filled in, signage has proliferated, and increasingly precious parking spaces became a concern for every store owner and shopper.

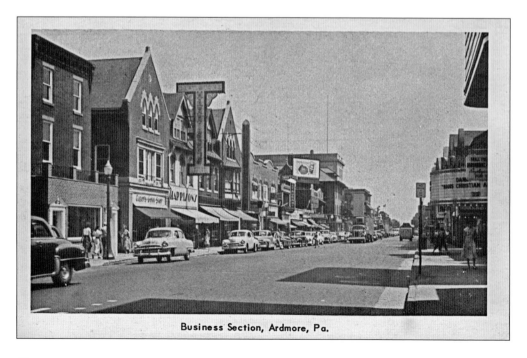

Business Section, Ardmore, Pa.

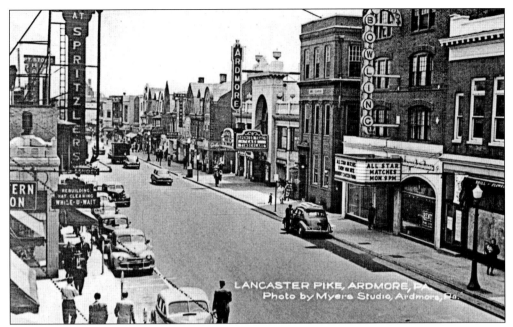

LANCASTER PIKE, ARDMORE BUSINESS DISTRICT. A panoramic view of the Ardmore business district, replete with two movie theaters, a bowling alley, bars, and sundry shops. Arguably, the 1940s represented the heyday of most Ardmore businesses, which swelled in variety and number to serve the workers of the nearby Autocar factory.

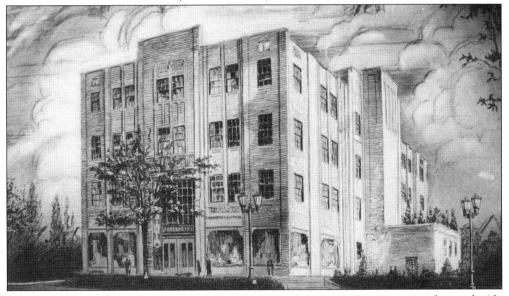

STRAWBRIDGE AND CLOTHIER, SUBURBAN SQUARE, ARDMORE. In contrast to the south side of the PRR tracks, where the factory workers and other members of the middle class lived and worked, Ardmore's north side served the upper class by cultivating high-end department stores and tearooms. In the late 1920s, the department store Strawbridge and Clothier, which for decades had operated out of Philadelphia, made retail history by opening one of the first suburban branches in the nation in Suburban Square. The business decision turned out to be a profitable one and helped to launch the meteorological rise of the suburban retail center.

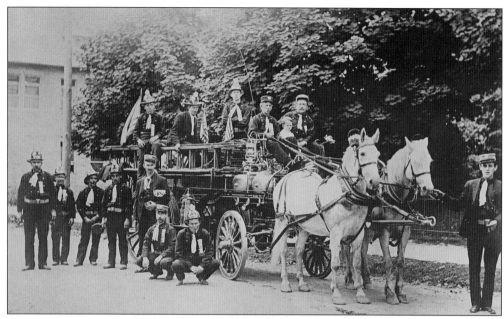

VOLUNTEER MERION FIRE COMPANY OF ARDMORE AROUND 1907. The first fire company in the township was Merion Fire Company No. 1 of Ardmore, which was established in 1889. Occupying a lot on the north side of Lancaster Pike, west of Ardmore Avenue, the firehouse also served as the first township police station. The baby boy sitting on the front of the hook and ladder is William Whelan, who later was elected as a Lower Merion commissioner. The following was taken from the *Main Line Times* in 1940: "To the Merion Fire Company last Saturday went credit for one of the most impressive shows ever staged on the Main Line—a three hour long parade commemorating the company's 50th anniversary. Fire companies, Legion Posts, bands and drum corps from municipalities within a radius of 50 miles or more in Eastern Pennsylvania and western New Jersey participated. The line of march extended three miles without a break."

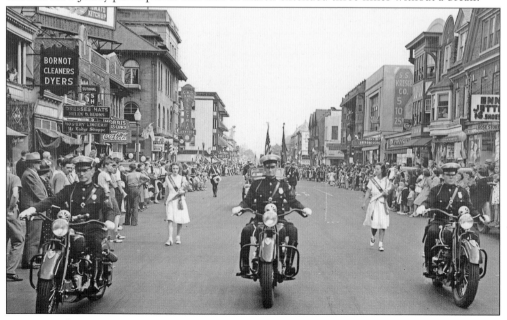

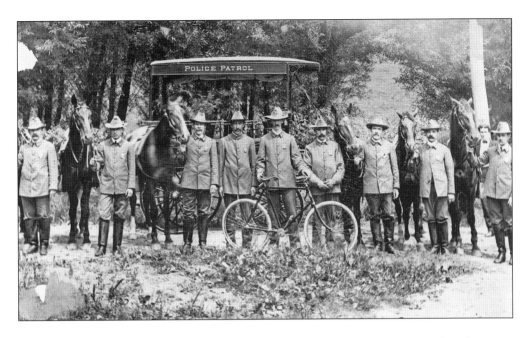

LOWER MERION POLICE FORCE AROUND 1904 AND 1910. Lower Merion's police force was established in 1900, when the township became designated as the first "Township of the First Class" in the state. At first, they wore army surplus hats and uniforms from the Spanish-American War and used bicycles and horses to patrol their assigned neighborhoods. By 1910, Lower Merion's finest donned a more traditional police uniform and had acquired their first motorized police wagon, manufactured by Ardmore's Autocar company.

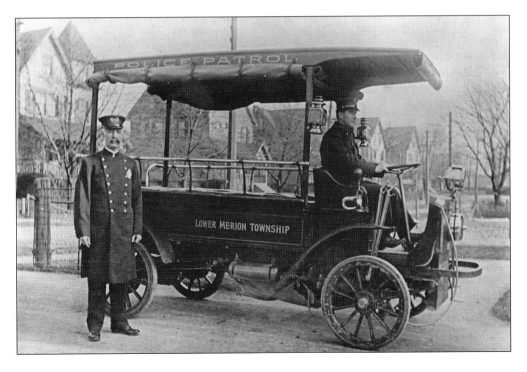

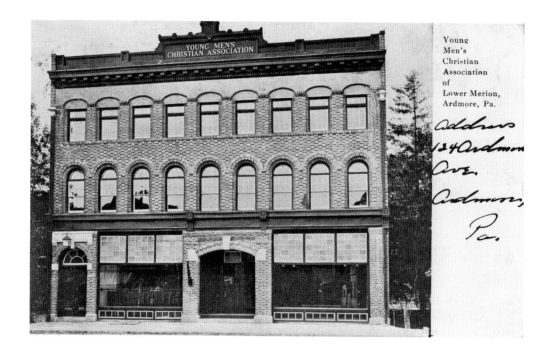

Young
Men's
Christian
Association
of
Lower Merion,
Ardmore, Pa.

*Address
134 Ardmore
Ave.
Ardmore,
Pa.*

YOUNG MEN'S CHRISTIAN ASSOCIATION OF LOWER MERION, FRONT AND BACK VIEWS.
Located on Lancaster Avenue, the YMCA also served as home to the Ardmore Free Library for a time. The tennis courts in the back were one of its main attractions. This photograph below was taken around 1910.

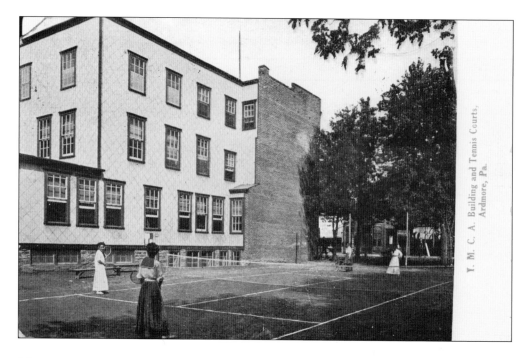

Y. M. C. A. Building and Tennis Courts, Ardmore, Pa.

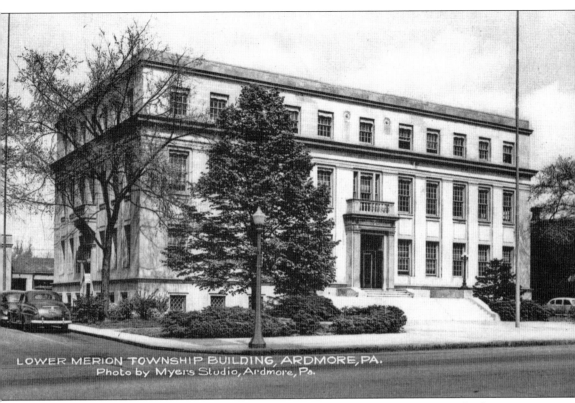

LOWER MERION TOWNSHIP BUILDING, ARDMORE, PA.
Photo by Myers Studio, Ardmore, Pa.

LOWER MERION TOWNSHIP BUILDING, ARDMORE. The original Beaux-Arts style, four-story building remains a prominent and dignified landmark in the Ardmore business district. Over the years, the police department, a magistrate's court, and even a third-floor janitor's apartment moved out of the building as new services, mandates, and technologies, now integral to the township, filled the structure's 24,000 square feet.

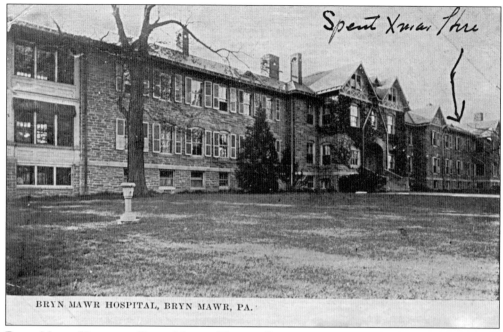

Spent Xmas here

BRYN MAWR HOSPITAL, BRYN MAWR, PA.

BRYN MAWR HOSPITAL, BRYN MAWR. The rapidly growing Lower Merion community soon had obvious need for a health-care facility. Dr. George S. Gerhard, an Ardmore physician, took on this project. With cash gifts, donated hospital supplies, and pro bono work by Philadelphia architect Frank Furness, Bryn Mawr Hospital took shape. It remains in use as a division of Main Line Health. The personal message reads: "My dear Dorthea, Thanks so much for your card and I appreciate your remembrance a lot – Am convalescing from a bad dose of pneumonia – Spent Xmas in hospital – will write a letter when stronger – Love all. Katherine. January 16, 1919."

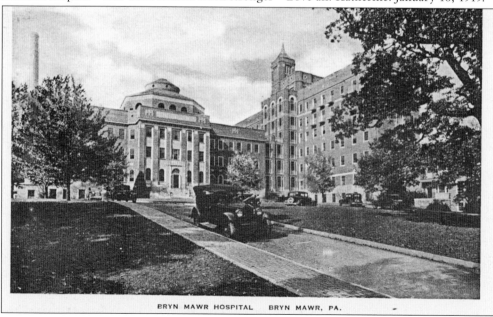

BRYN MAWR HOSPITAL BRYN MAWR, PA.

BRYN MAWR HOSPITAL, BRYN MAWR. Here is a later addition to the Bryn Mawr Hospital complex, which is currently operated by Main Line Health.

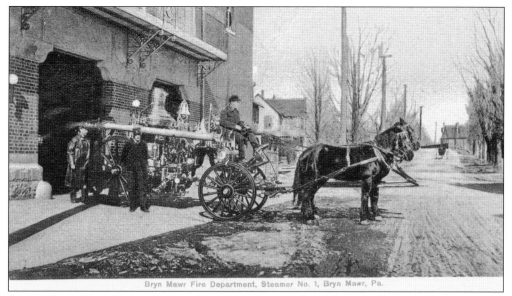

Bryn Mawr Fire Department, Steamer No. 1, Bryn Mawr, Pa.

BRYN MAWR FIRE DEPARTMENT, STEAMER NO. 1. This fire station has stood at the corner of Lancaster and Merion Avenues since 1903. The members of the Bryn Mawr Fire Company continue the long-standing tradition of participating in parades as a full company to this day, including a marching unit with a band and color guard. This colorized card dates to 1910 and was printed in Germany.

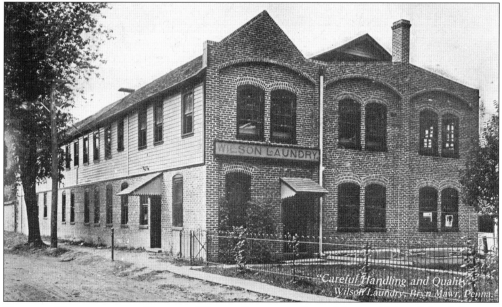

CAREFUL HANDLING AND QUALITY WILSON LAUNDRY, BRYN MAWR. Although it might seem unusual to have a postcard for such a mundane service as dry cleaning, Wilson Laundry is actually a prime example of a successful business-turned-institution along the Main Line. Located on the south side of the tracks in Ardmore, Wilson Laundry served the upper classes from the north side of the tracks, from Philadelphia to Malvern, for 60 years. In 1895, C. E. Wilson established his business at Summit Grove and Lancaster Avenues. The plant had approximately 100 employees when it was sold in 1955.

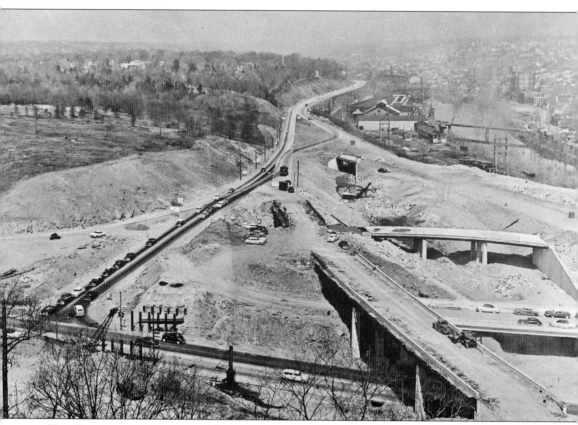

THE SCHUYLKILL EXPRESSWAY INTERCHANGE AT CITY LINE AVENUE. The harbinger for the modernizing of Lower Merion was the Schuylkill Expressway. An emphasis on the new and the modern prevailed over much of Lower Merion's seasoned stone building stock and architecture. New businesses emerged up and down the nascent U.S. 1 south. The stretch was soon known as the Golden Mile, referring to the tax revenue it generated.

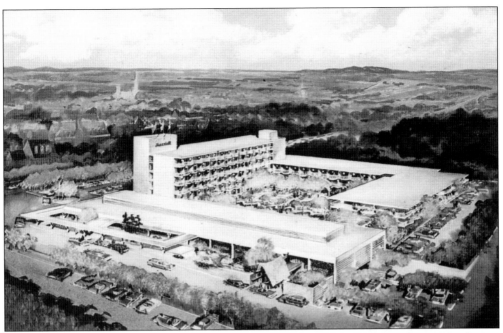

MARRIOTT MOTOR HOTEL, BALA.
Located at the City Line Avenue interchange, this sprawling motel had over 300 rooms and three themed restaurants. At right, a postcard shows the interior of the Polynesian restaurant with the wonderfully tacky description: "The exotic Kona Kai Polynesian restaurant and cocktail lounge features authentic food and drinks served in a romantic South Seas atmosphere with waterfalls and tropical foliage."

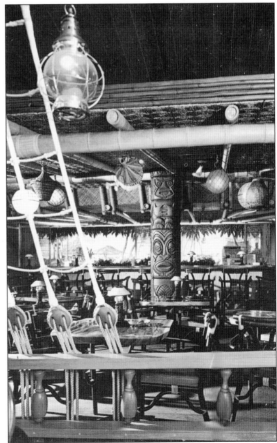

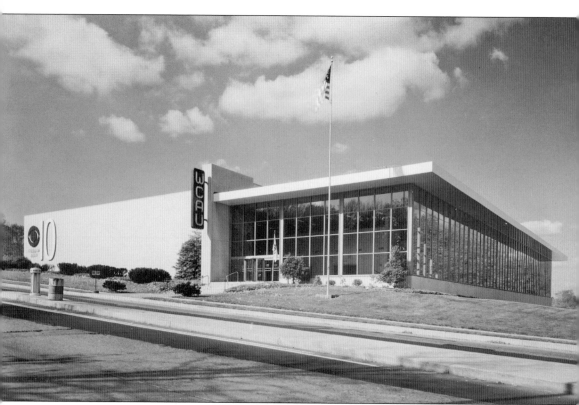

CHANNEL 10 BUILDING, CITY AVENUE AND MONUMENT ROAD, BALA. An archetypal example of 1950s architecture, the Channel 10 building was designed by George Howe and Robert Montgomery Brown as a state-of-the-art facility in 1952, when it was constructed. A staged Western town was built in the lot behind the station, where a daily Western was televised live.

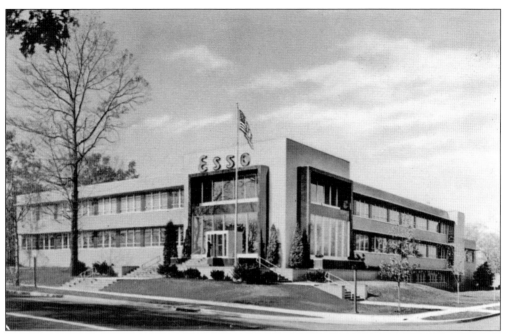

ESSO STANDARD OIL COMPANY, PENNSYLVANIA DIVISION HEADQUARTERS, BALA. Here is another typical modern building located along the Golden Mile on City Line Avenue and Esso Road.

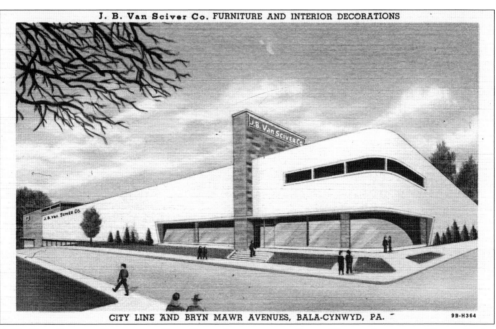

J. B. Van Sciver Co. FURNITURE AND INTERIOR DECORATIONS

CITY LINE AND BRYN MAWR AVENUES, BALA-CYNWYD, PA.

9B-H364

J. B. VAN SCIVER COMPANY, CITY LINE AVENUE AND BRYN MAWR AVENUES, BALA. At the time, the construction of the $1 million store for the J. B. Van Sciver Furniture Company was one of the largest development projects in Lower Merion history. A forerunner of today's big-box stores, the building was three stories high, encompassed a full block, and boasted 125,000 square feet of display space. The parking lot had the capacity to hold 500 cars. The building also featured a rooftop garden, an unusual amenity for the 1950s.

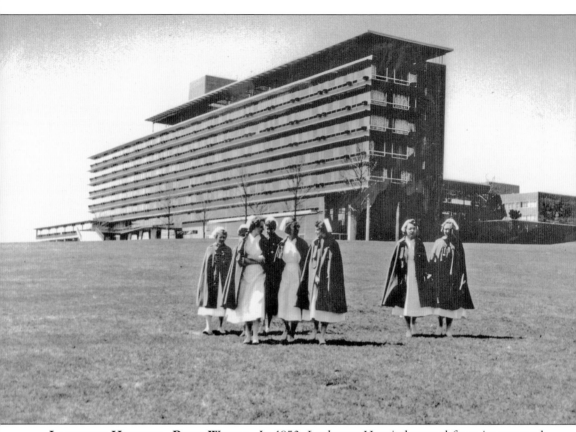

LANKENAU HOSPITAL, PENN WYNNE. In 1953, Lankenau Hospital moved from its cramped Philadelphia location at Girard and Corinthian Avenues to a sprawling 93-acre site in the vicinity of City Line Avenue and Lancaster Pike in Lower Merion. Vincent Kling, the architect for the new complex, won a first-place award in architecture for his design.

Five

SCHOOLS AND LIBRARIES

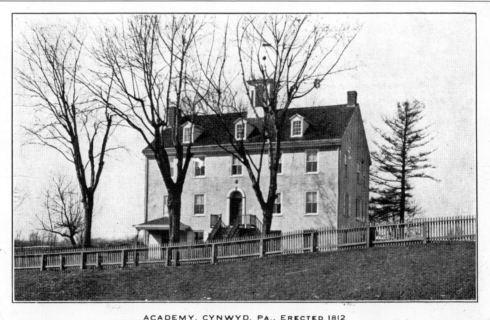

ACADEMY, CYNWYD, PA., ERECTED 1812

LOWER MERION ACADEMY, CYNWYD. The Academy has been one of the landmark buildings of the region since its erection in 1812. Quaker Jacob Jones bequeathed funds and 9 acres of land to create the first schoolhouse in Lower Merion dedicated in perpetuity to public education without regard to religion, race, or gender. In 1914, the Lower Merion School District built the Cynwyd Elementary School, followed by the construction of the Bala Cynwyd Middle School in 1938 on the land, thus continuing the legacy of public education first institutionalized by the Academy trustees. In 2002, the Academy was added to the National Register of Historic Places. It now serves as the beloved headquarters of the Lower Merion Historical Society. This white-border postcard is a good example of this popular style for postcards from 1915 to 1930. The style was also developed as a method to save ink.

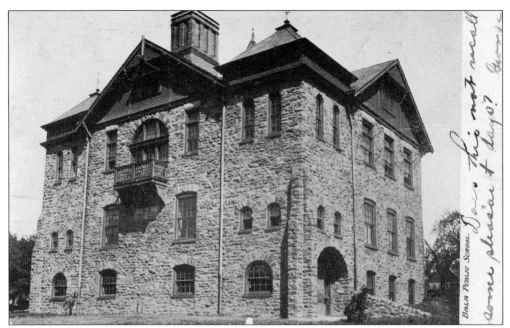

BALA ELEMENTARY PUBLIC SCHOOL. "Does this not recall some pleasant days? – George" reads the personal inscription on the front. Constructed in 1888, the school was a stone structure on the southeastern corner of Union and Bala Avenues at 49 Bala Avenue in Bala Cynwyd. An addition was built in 1909 and a power plant added in 1916. The school was adjacent to a township playground, until it was closed in 1974 and demolished a few years later. The site now contains a township-owned gym and meeting center.

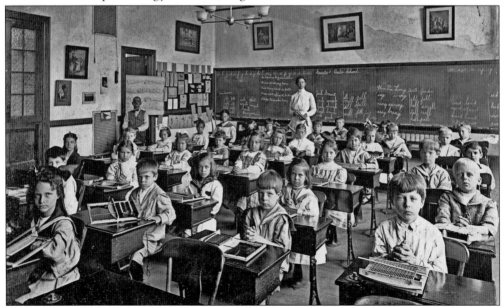

FIRST GRADE CLASS AT THE BALA ELEMENTARY SCHOOL, 1911. Even back in 1911, this was a school of excellence. Pictured are Nellie Brown, the teacher, and her class with Mr. Edwards, the janitor (far left). In 1911–1912, eight staff members taught grades one through eight, with Sara A. Fite as principal.

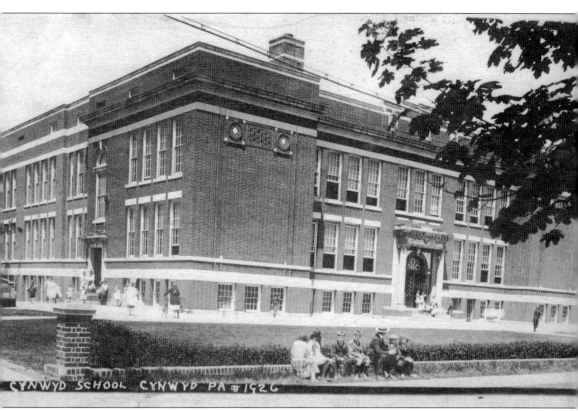

CYNWYD ELEMENTARY SCHOOL. Cynwyd School is located at 101 West Levering Mill Road in Bala Cynwyd. It was built in 1914, at a cost of $57,010, on land owned by the trustees of the Lower Merion Academy. The architects were Savery, Scheetz, and Savery. In September 1916, 153 students were enrolled; in 2009, enrollment reached 450. An additional classroom wing, designed by Demchick, Berger, and Dash Associates in 1967, was replaced in 1999 by a two-story brick addition designed by architects Einhorn, Yaffee, and Prescott. An atrium allows a two-story view of the exterior of the 1914 wall.

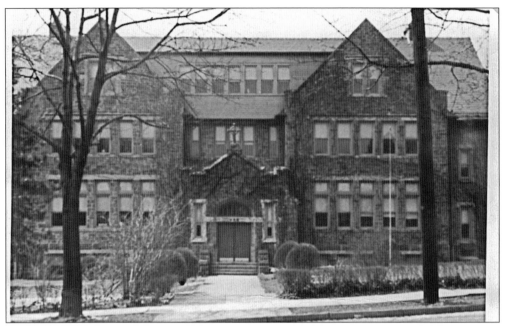

St. Matthias School, Bala. The St. Matthias Roman Catholic parish school and convent was built in 1915 in the same picturesque architectural style as the church. When the parochial school opened, it consisted of six grades with a total enrollment of just 19 pupils, who were taught by two Sisters of Mercy. It was demolished in 1971 for a new parish school, gymnasium, cafeteria, and social hall.

Miss Roney's School for Girls, Bala. Private schooling was an attractive option for some Main Line neighborhood families. This niche was filled by a number of small private finishing schools for young ladies, such as Miss Roney's. Some of these schools had small enrollments and, therefore, were easily accommodated in private residences. However, to create her school, Miss Roney acquired two houses along Edgehill Road in Bala and connected them with a hallway. After closing, this hallway was removed, and the two houses were returned to their previous situation as separate residences.

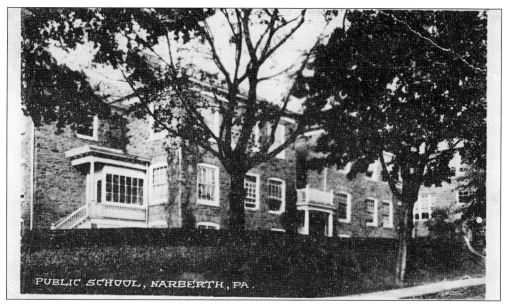

NARBERTH PUBLIC SCHOOL. Narberth Public School was a two-story, native-stone building on the northeastern corner of North Essex and Sabine Avenues. It was erected around 1892 by Lower Merion School District as an elementary school but was sold to Narberth School District three years later, when Narberth was established as a separate borough. From 1909 to 1923, the school's curriculum also included courses for high school. An adjacent two-story, stone building was erected on the brow of the hill on Sabine Avenue in 1917. Both structures were demolished in 1961.

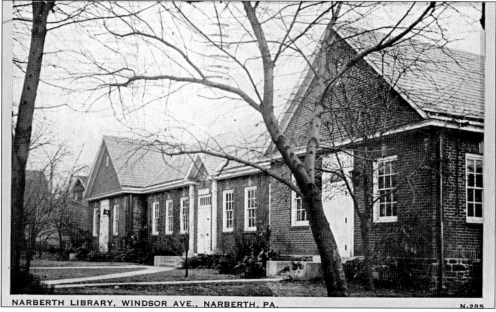

NARBERTH LIBRARY. The Narberth Community Library was built of brick around 1928. In the same structure, on the left, is the American Legion Hall; on the right of the library is the Girl Scout room, which is also used by the Women's Clubs and as a polling station. Since the 1950s, when this image was taken, handicapped-accessible ramps and longer concrete stairs have been added to the front.

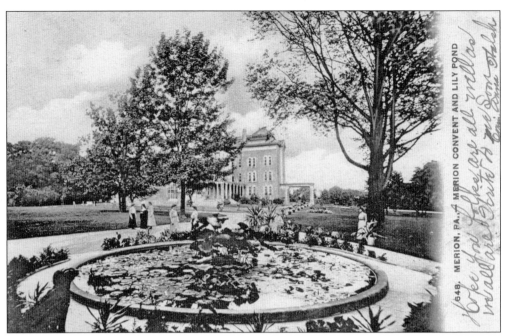

MATER MISERICORDIAE CONVENT AND ACADEMY, MERION. In 1884, a contingent of Catholic Sisters from the Sisters of Mercy arrived in the area and created a Merion chapter. By 1892, they had established a convent and Mater Misericordiae Academy (Latin for Mother of Mercy), which was the forerunner of Merion Mercy Academy for Girls and Waldron-Mercy Academy for Boys. In 1987, these two academies merged to become the Waldron Mercy Academy in a newly renovated facility. This suburban campus remains as a landmark and the headquarters for the Sisters of Mercy who have been fulfilling their ministry of education for young girls and boys.

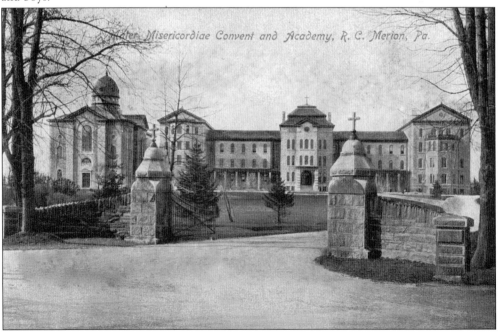

Mater Misericordiae Convent and Academy, R. C. Merion, Pa.

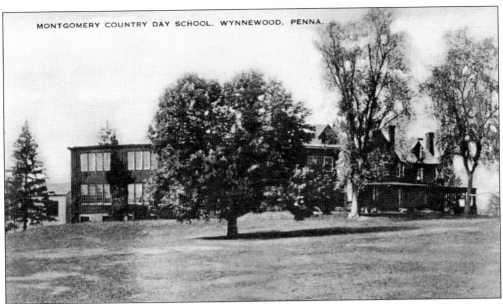

MONTGOMERY COUNTY DAY SCHOOL, WYNNEWOOD. The Montgomery County Day School was originally located in this resplendent old Main Line mansion located on Montgomery Avenue and North Wynnewood Road. However, in 1949, when it came time for the school to expand, the property was sold to Temple Adath Israel, and then to Main Line Reform Temple Beth Elohim four years later. In 1960, the old mansion was demolished to make room for a new structure that now houses the temple and its religious school.

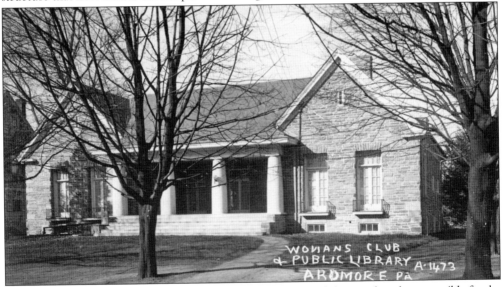

WOMEN'S CLUB AND PUBLIC LIBRARY, ARDMORE. Women's clubs were largely responsible for the promotion and evolution of what is now the renowned Lower Merion library system. In 1899, the Women's Club of Ardmore rented a room in the Merion Title and Trust Building and established a library, not only for the use of the club, but for the community at large. The personal message on the back reads: "Dear Mrs. S. I did not know of Clara's death until you wrote and then Dot went to Chesapeake and she told me. I am awful Sorry. As that is the [illegible] she has buried all they had. But Gods will be done – love W. Walls. (Take good care of your self.) August 2, 1923."

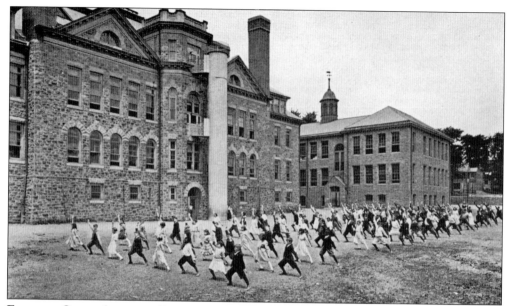

Exercise Class, Ardmore Public School, Ardmore, 1925. The original Ardmore School was built in 1875 and burned down in 1900. The school was rebuilt over the following years using native stone and functioned as an elementary and high school until 1910. A spiral, toboggan fire escape was added in 1916, much to the delight of the male students, who used it as a giant slide. The structure was used solely as an elementary school until its closure in 1963.

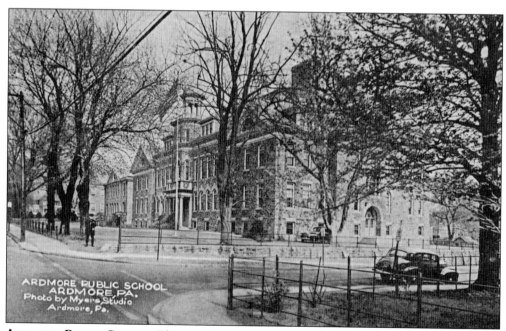

Ardmore Public School. This sturdy stone structure was demolished, with great effort, in 1965. Currently the site is used as housing for the elderly.

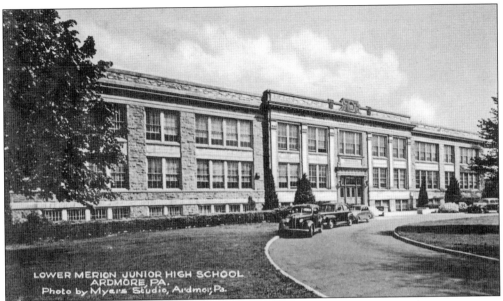

LOWER MERION JUNIOR HIGH SCHOOL, ARDMORE. Also called Ardmore Junior High School, this building was constructed of Holmsburg granite and Indiana limestone in 1921–1923 by Italian stonemasons. It opened in February 1924. In 1939–1940, Edward Holyoke Snow was the principal, with a teaching staff of 37 for grades seven to nine. It closed in 1978 due to declining enrollment and was demolished in 1992 after an extensive legal battle.

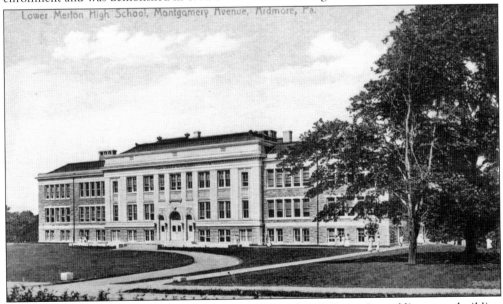

LOWER MERION SENIOR HIGH SCHOOL, ARDMORE. This 1910 granite and limestone building was demolished in 1963 and replaced by a structure that was designed by H. A. Kuljian and Company. The site is shared with the Lower Merion School District administration building. In 1912–1913, twenty-one staff members were employed under Principal "Professor" Charles B. Pennypacker. In 1939–1940, George H. Gilbert was principal, with a teaching staff of 61. The 1963 structure is currently being demolished for a new facility that accommodates modern safety codes and student requirements.

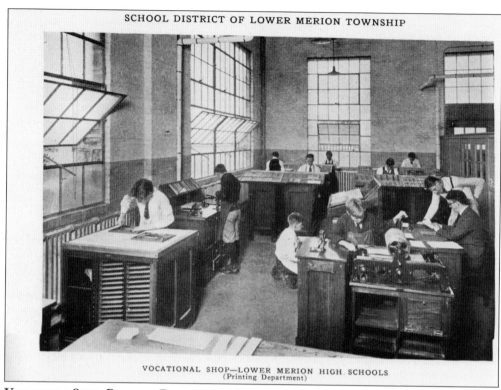

VOCATIONAL SHOP—LOWER MERION HIGH SCHOOLS
(Printing Department)

VOCATIONAL SHOP, PRINTING DEPARTMENT, LOWER MERION SENIOR HIGH SCHOOL. According to Lower Merion School District's Public School Directory of 1928–1929, seniors at the high school had a wide range of choices for electives, including cabinet making, architectural drawing, home decoration and design, dietetics, millinery, advanced printing, machine construction, and "social problems."

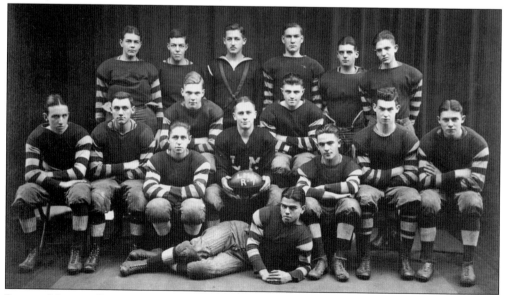

LOWER MERION SENIOR HIGH SCHOOL FOOTBALL TEAM, 1918. The football team is shown only nine years after the Lower Merion High School at Montgomery Avenue was founded.

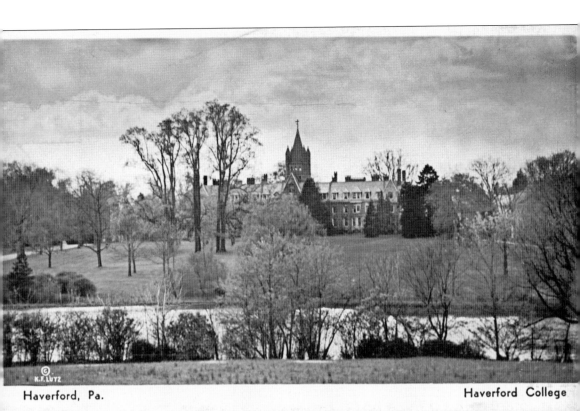

Haverford, Pa. Haverford College

HAVERFORD COLLEGE, HAVERFORD. Considered one of America's leading liberal arts colleges, Haverford was founded in 1833 on the Quaker values of individual dignity, academic strength, and tolerance. The campus is comprised of more than 200 acres and is, in itself, a nationally recognized arboretum, with more than 400 species of trees and shrubs, a 3.5-acre duck pond, multiple gardens, and wooded areas. In 1980, it began enrolling women. The college now operates more than 50 academic, athletic, and residential buildings.

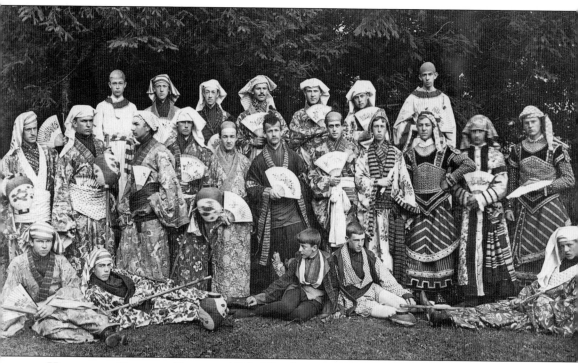

HAVERFORD COLLEGE, CLASS OF 1888. The class of 1888 is pictured during a popular annual celebration in which they donned costumes and burned their most despised textbook of that year.

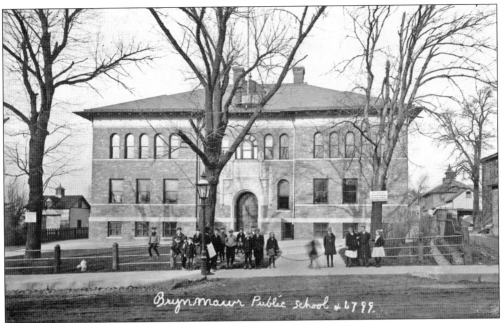

Bryn Mawr Public School #6799.

BRYN MAWR ELEMENTARY PUBLIC SCHOOL. The Bryn Mawr School was located at 913–929 West Lancaster Avenue, between Merion and Warner Avenues, opposite Prospect Avenue in Bryn Mawr. It was built of native stone in 1870. As of June 1915, it had a staff of 16 members who taught grades one through eight, with Sophie Kefer as principal. It closed in the fall of 1915, when the building was rented to various local organizations, and it then was reused briefly as a school in 1923–1924, until the new Lower Merion Junior High School opened. The building was sold to the Moose Home of Bryn Mawr, which used it for over a decade.

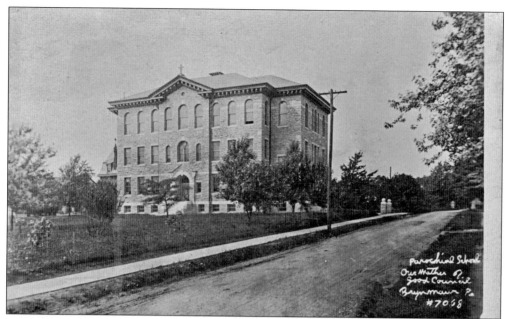

OUR MOTHER OF GOOD COUNCIL, BRYN MAWR. The oldest Roman Catholic church in the township, Our Mother of Good Counsel Church was founded in 1885, although the church building wasn't constructed until 1896. Augustinians served the parish, and the Sisters of Mercy were in charge of the school, which was built about 1904. A convent was added in 1912 and a new school in 1965. The parish recently celebrated its 125th anniversary.

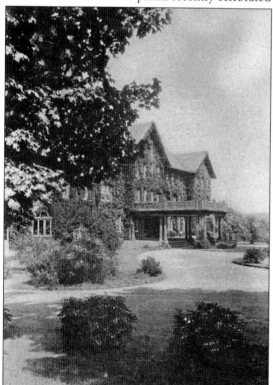

MISS WRIGHT'S SCHOOL, BRYN MAWR. Eliza Mary Wright founded this independent girls' school for grades 7 through 12 in 1903. Two years later, Wright bought 7 acres of land and designed and commissioned this fine stone building in addition to a gym, a stable, a basketball court, and an infirmary. After Wright's death in 1930, her brother Guier and his wife, Dorothy Battles, continued to operate the school for another six years. When the school closed in 1936, it was bought by Bryn Mawr College and renamed Brecon Hall. The building was repurposed in 1981. Today it is used as an undergraduate student dorm.

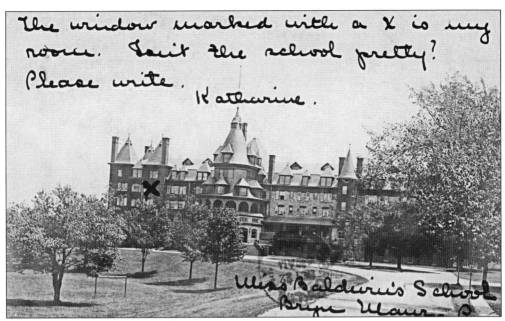

The window marked with a X is my room. Isn't the school pretty? Please write. Katharine.

Miss Baldwin's School Bryn Mawr.

MISS BALDWIN'S SCHOOL, BRYN MAWR. "The window marked with an X is my room. Isn't the school pretty? Please write. Katherine." The Baldwin School was founded by Florence Baldwin in 1888 under the motto, "From thinking girls, to accomplished women." At first, Baldwin ran the school out of her home. At the time, many considered the education of girls unnecessary and thought it constituted an unwarranted expense. In 1896, she leased the Bryn Mawr Hotel to house her school and teach some 200 girls from seven years old to college-age during the winter months. The Baldwin School, incorporated in 1905, purchased the hotel and the surrounding 25 acres in 1922 for the sum of $240,000. Fifty years later, the boarding department was terminated for economic reasons, and the students' rooms were converted to teachers' apartments. Thirteen girls were enrolled in the first class; in 2010, enrollment numbered almost 600 girls. The school now boasts of an alumni community of more than 4,000 women.

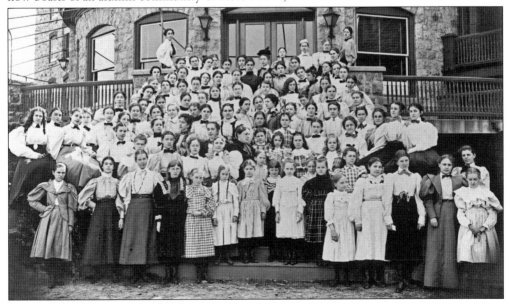

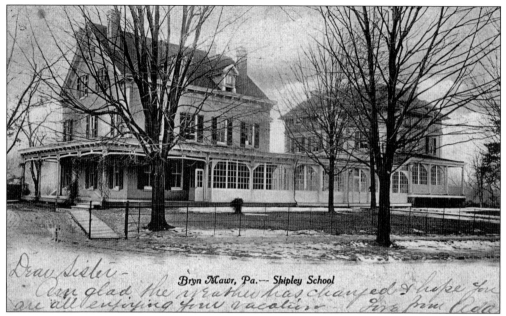

Bryn Mawr, Pa. — Shipley School

*Dear Sister —
am glad the weather has changed & hope you are all enjoying your vacation. Love from Ada*

SHIPLEY SCHOOL, BRYN MAWR. The Shipley School was founded on a portion of its present site in 1894, across the street from Bryn Mawr College, by three Sisters who opened the Miss Shipley's Bryn Mawr School to prepare young women for college. The school enjoyed a renaissance in the 1970s, in which the administrators were able to update the physical plant and build new buildings and playing fields.

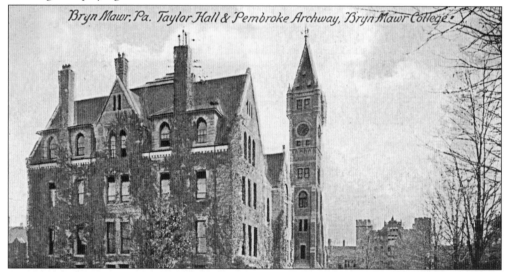

Bryn Mawr, Pa. Taylor Hall & Pembroke Archway, Bryn Mawr College.

TAYLOR HALL AND PEMBROKE ARCHWAY, BRYN MAWR COLLEGE. The founding of Bryn Mawr College carried out the will of Dr. Joseph Wright Taylor, who wanted to establish a college "for the advanced education of females." Bryn Mawr's administration building was designed by Addison Hutton in a high Victorian Gothic style with a distinctive bell tower. Bryn Mawr College has many long-standing traditions; for example, each year, after all senior work is complete, every senior goes to Taylor Tower and rings the bell to announce her upcoming graduation. The number of rings corresponds to her class year (e.g., members of the class of 2012 will ring the bell 12 times).

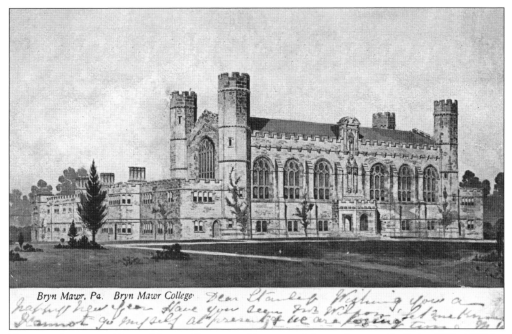

THOMAS LIBRARY, BRYN MAWR COLLEGE, DAY AND NIGHT SCENE. Built in 1901–1907 by the architect and builder Cope and Stewardson, Thomas Library was named after Bryn Mawr's first dean and second president, M. Carey Thomas. It was the main library until 1970, when the Mariam Coffin Canaday Library opened. Today this structure is designated a national landmark and is used for lectures, performances, and public gatherings. The Great Hall, inspired by the dining hall at Wadham College in Oxford, England, is built with ashlar gray stone and lined with oak paneling. The bottom image is, once again, a contrived night scene, with painted-in ominous clouds and a full moon—to better illuminate the building.

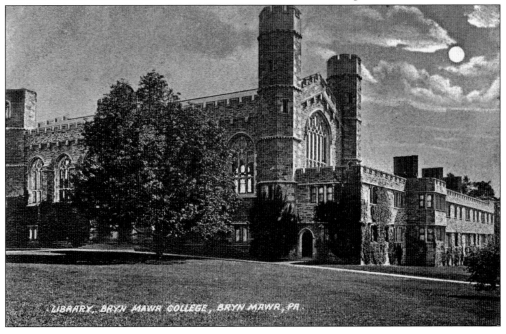

LIBRARY, BRYN MAWR COLLEGE, BRYN MAWR, PA.

May Day, Bryn Mawr College, 1924. May Day, an English tradition dating back to Roman times, marks the end of winter and the arrival the growing season. This long-standing tradition is reenacted at Bryn Mawr College annually and features students, faculty, and staff celebrating by dancing around the maypole. There are also plays, concerts, and general revelry.

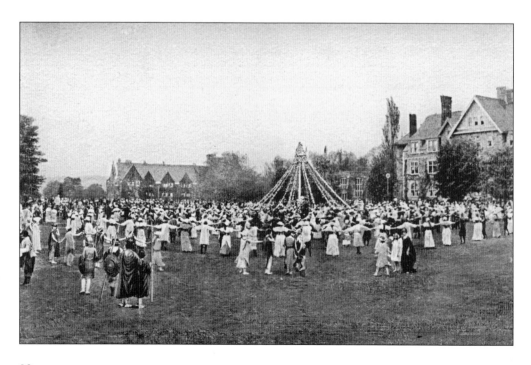

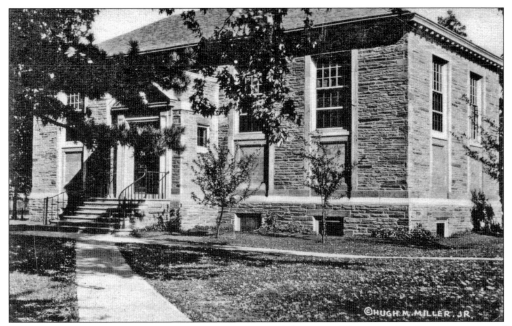

LUDINGTON MEMORIAL LIBRARY, BRYN MAWR. The main library and reference center of the township, Ludington began its long and illustrious operation in 1916 with an inventory of 20 books and two dozen chairs. Charles Ludington, vice president of Curtis Publishing, generously donated the funds to build a permanent home for the ever-expanding collection in 1926. A children's wing was added in 1954 and a major addition built in 1967. The library is now undergoing a major green renovation, complete with a café and green roof.

KISTLER GARDEN, ROSEMONT COLLEGE, ROSEMONT. In 1920, Sisters of the Society of the Holy Child Jesus purchased the Sinnott estate in Rosemont, along with its great, 32-room manor house, Rathalla. Since its founding, Rosemont College of the Holy Child Jesus has served as a Catholic liberal arts college for women. Rosemont College is part of a consortium with Villanova University and Cabrini College, in which they share courses, facilities, and special educational activities.

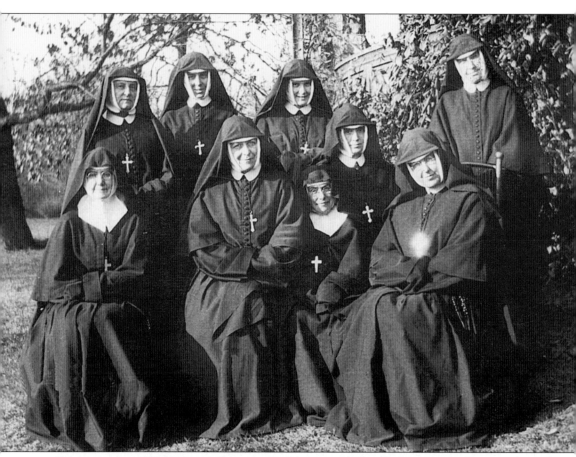

SISTERS OF THE HOLY CHILD, ROSEMONT COLLEGE. Mother Dolores Brady, first president of Rosemont College, is seated second from the left.

Six

HOUSES OF WORSHIP

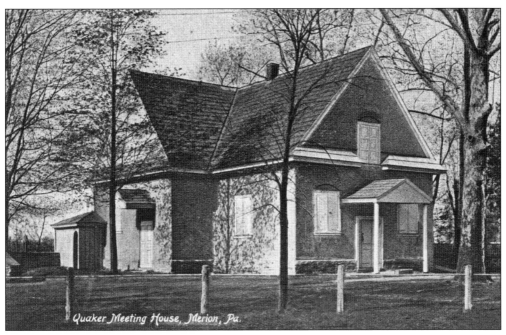

Quaker Meeting House, Merion, Pa.

QUAKER MEETING HOUSE, MERION. The Religious Society of the Friends' Merion Meeting House is a national treasure and the defining building of the community. It has been in continuous use since its construction in 1695. Members of the society donated most of the materials, and from those, the building was cobbled together by volunteers and paid laborers over a span of 30 years. Pennsylvania's European heritage can be traced back to William Penn and his "Holy Experiment"—freedom from unjust persecution, freedom of religion, and peaceful coexistence. Today many still view the meetinghouse as a part and reminder of Penn's vision and egalitarian values. The 325th anniversary of the founding of the Welsh Tract in America was celebrated in 2007. This simple structure has been designated as a National Register Landmark and is part of a local historic district.

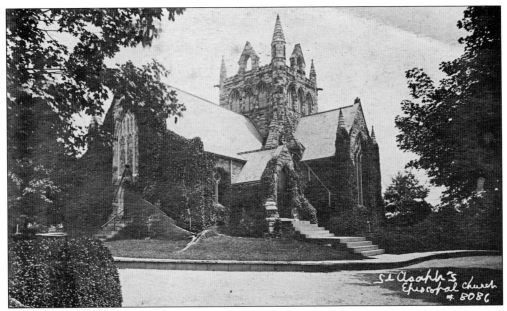

St. Asaph's Episcopal, Bala. Modeled after St. Asaph Cathedral in Wales, this Episcopal church was built amidst farms, close to the Schuylkill Valley spur of the Pennsylvania Railroad and the (still unpaved) City Line Avenue. The first service in the Victorian Gothic building took place on March 24, 1889. When the first rector, Rev. Frederick Burgess, arrived a few months later, the donations collected at his first service were sent to the victims of the recent, devastating Johnstown flood, beginning a long legacy of outreach and good works that continues to this day.

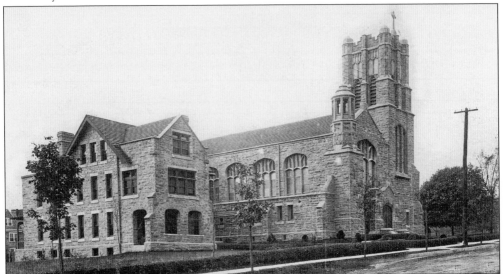

St. Matthias Roman Catholic Church, Bala. To attract developers and residents to this emerging suburban community, the archbishop of Philadelphia established St. Matthias Parish on February 2, 1906. Seven months later, on October 7, 1906, the cornerstone was laid and construction of the church and rectory began. Built in the English style of Benedictine and Augustinian monastery churches of the 12th and 13th centuries, this picturesque structure is "strong in its foundation, reverent in its atmosphere, and beautiful in its simplicity."

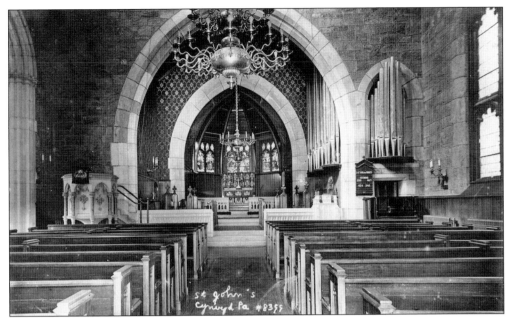

St. John's Episcopal Church, Cynwyd. St. John's is the second oldest Episcopal church in Lower Merion Township (Church of the Redeemer claims the superlative of being the first). The first service was held on August 6, 1863, while the Civil War was raging. At the beginning of the century, three of the original board-and-batten church buildings along Levering Mill Road in Bala Cynwyd were replaced with stone buildings, including the church, parish hall, and rectory. Today it is still considered one of the lovelier churches in the area, complete with the stained glass windows that were made by Nicola D'Ascenzo Studios of Philadelphia and Hardman Studios of Birmingham, England.

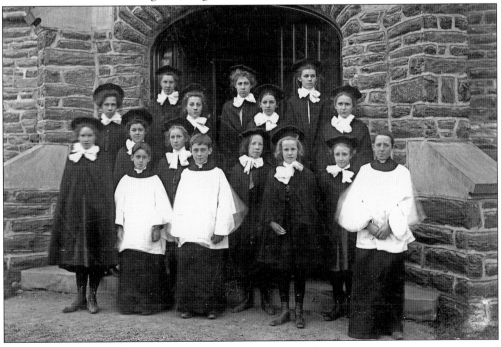

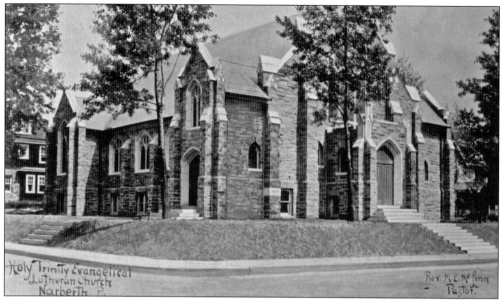

HOLY TRINITY EVANGELICAL LUTHERAN CHURCH, NARBERTH. This Lutheran community was established on January 15, 1922. The newly formed congregation of 90 first met at the YMCA in Narberth, but cramped conditions led to the decision to construct the current edifice at the southeast corner of Woodbine and North Narberth Avenues. Ground was broken in the spring of 1924; the church was formally dedicated on May 24, 1925. The building was expanded in the late 1940s.

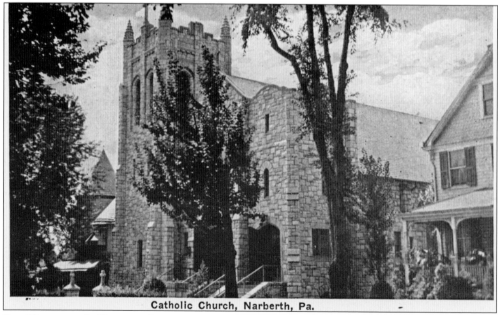

ST. MARGARET'S ROMAN CATHOLIC CHURCH, NARBERTH. St. Margaret's Roman Catholic Church was established in 1900. An elementary school building on Forrest Avenue, Narberth, was added in 1926. A new school and parking lot were constructed across the street from the church. With the closing of many parish schools, St. Margaret Elementary School now draws pupils from seven parishes. A centennial book was published in 2000.

ST. PAUL'S LUTHERAN CHURCH, ARDMORE.
Established by early German immigrants in
1769, St. Paul's was a log country church for
60 years. In 1833, a new location was selected
and a new church built near the Ardmore
town center on Lancaster Pike, west of Church
Road. At this time, the church assumed the
corporate name of the Evangelical Lutheran
Congregation of Saint Paul's Church. The
church was relocated again in 1941 to
Argyle and Wynnewood Roads. The Luther
Parsons Bell Tower was erected in 1957.

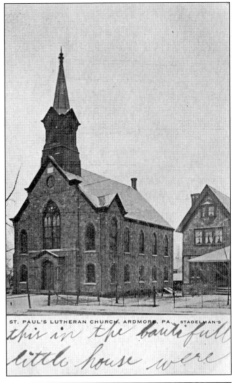

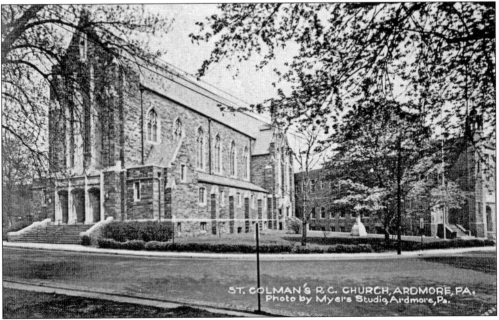

ST. COLEMAN'S ROMAN CATHOLIC CHURCH, ARDMORE. Saint Colman's Roman Catholic Church
was founded in 1907. Ardmore had a large Irish population at the time. In fact, the neighborhood
derived its name from a town in County Waterford in southern Ireland. Rev. James J. Carton, an
Irish immigrant, was appointed the first rector. The school opened in 1915 under the direction of the
Sisters of Saint Joseph from Chestnut Hill. The present church building was completed in 1926.

MOUNT CALVARY BAPTIST CHURCH, ARDMORE. In the late 19th century, as a burgeoning African American community was taking root in Lower Merion, parishioners of a local white Baptist church (located at Lancaster Avenue and Woodside Road) invited them to share their facilities. From 1875 to 1893, black and white families attended services together, and their children were educated side by side at the Sunday school. However, as the African American community continued to grow, plans were made to found separate institutions: the first was Zion Baptist Church, chartered in 1894. Mount Calvary Baptist, also in Ardmore, was organized at the home of Flora Woodson of Simpson Road in January 1906. Within a few decades, the community had erected a church and a Sunday school, as well as several successful social programs. Pictured is one of the Sunday school classes of 1956.

ST. MARY'S EPISCOPAL CHURCH, ARDMORE. Located on Ardmore Avenue, a block off Lancaster Avenue, St. Mary's Episcopal Church was designed by architects Furness and Evans and constructed in 1887. In 1895, a laundry, also named St. Mary's, was established by the parish to create jobs for women. The personal image on the back reads: "Yes dear. I know I'm handsome." This card was printed in Germany.

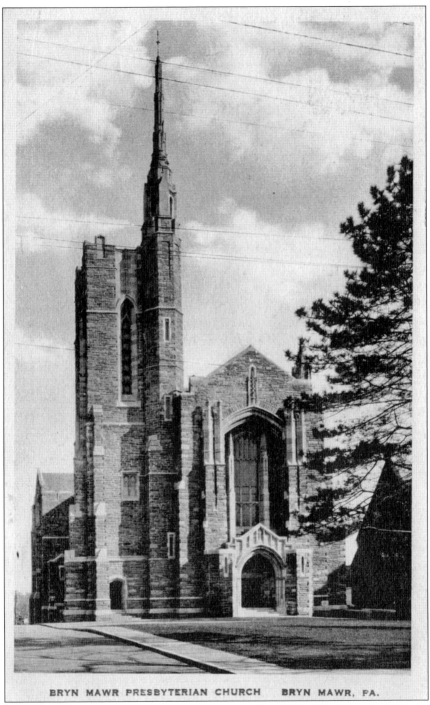

BRYN MAWR PRESBYTERIAN CHURCH BRYN MAWR, PA.

BRYN MAWR PRESBYTERIAN CHURCH, BRYN MAWR. Bryn Mawr Presbyterian Church had its informal beginning in January 1873 in the Temperance Hall on Lancaster Pike. The group soon after purchased a larger piece of real estate on Montgomery Avenue, where the church stands to this day. Bryn Mawr Presbyterian's first pastor, the Reverend William H. Miller, came to the parish in 1874 and stayed for 33 years, helping to build the church in 1886.

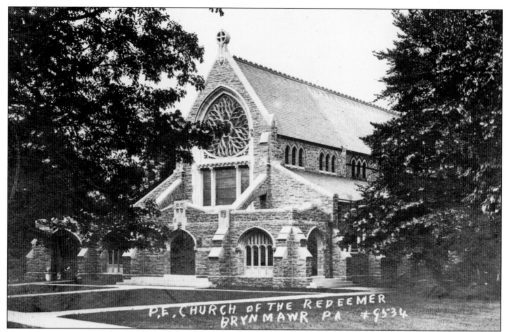

CHURCH OF THE REDEEMER, BRYN MAWR. The Church of the Redeemer (Episcopal) in Bryn Mawr was established in 1851. The parish's first church, at Lancaster and Buck Lanes, is no longer standing. In 1879–1881, a new church, designed by Charles M. Burns Jr., with chancel and tower in the Gothic style of architecture, was built at Pennswood and New Gulph Roads to serve the Main Line parishioners. The parish complex sits on 11 acres of land that includes the church, the churchyard, a parsonage, a memorial garden, and cemetery, which gives testimony to the enduring appeal of familiar architectural forms in tranquil settings.

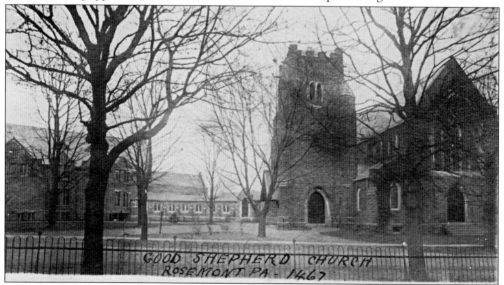

GOOD SHEPHERD CHURCH, ROSEMONT. The Church of the Good Shepherd was built in 1893 with funds in memoriam to Augusta Graham French, whose husband was a partner in the successful pharmaceutical company Smith, Kline, and French. Since 1989, Good Shepherd has been affiliated with the Episcopal Synod of America, also known as "Forward in Faith."

Seven

Sports, Recreation, and Parks

Barnes Foundation, Merion. Chartered as a privately endowed, educational nonprofit by the Commonwealth of Pennsylvania in 1922, the Barnes Foundation is one of the largest repositories of impressionist, post-impressionist, and modern art in the world. Founder and avid art collector Dr. Albert Barnes was an infamous Lower Merion personality and Philadelphia native. After making his millions from the invention and patent of a pharmaceutical for newborns that prevented eye infections, Barnes dedicated himself to writing books on art education and researching underappreciated and undiscovered artists. As of this writing, the foundation is building a new repository along Philadelphia's Ben Franklin Parkway, thus, moving the collection out of its ancestral residential neighborhood to a more urban locale.

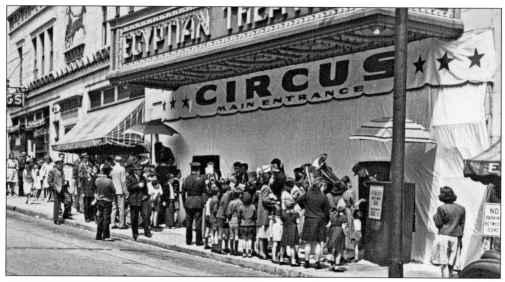

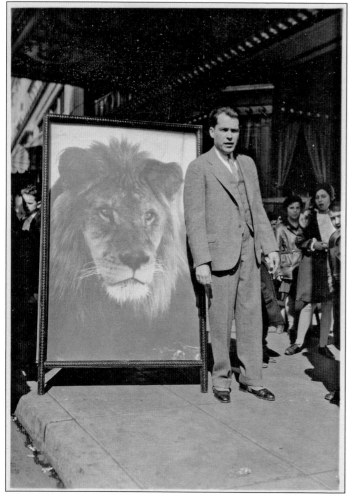

EGYPTIAN THEATER, BALA. P. J. Lawler built this ornate, unique, art deco theater on Bala Avenue in 1927. Designed with ancient Egyptian reliefs on its exterior and colorful reliefs and murals in its interior, this building housed vaudeville acts, the circus, and later a movie theater. Jim Conway, the theater manager, was responsible for movie selections and the scheduling of vaudeville acts and circus tours. In this photograph at left, he is standing in front of an advertisement for the famous Leo the Lion.

INTERIOR EGYPTIAN THEATER. Admission was 10¢ but could get as expensive as 35¢ for the vaudeville shows. Next door to the theater, only a few feet from the box office, was Goldische's Candy Store where, for just a penny, you could get a supply of Good and Plenty or Goldenberg's Peanut Chews. The theater has been renamed the Clearview Bala Theater and remains a neighborhood treasure. The theater's Egyptian-themed decorative walls and columns were covered with fabric, but not destroyed, so that it could be revealed in the future. The ceiling centerpiece is still exposed to the wonderment of the general public—just remember to look up. (Courtesy of Library of Congress, Prints and Photographs Division, HABS, Reproduction Number HABS PA 46-Bala, 2-9.)

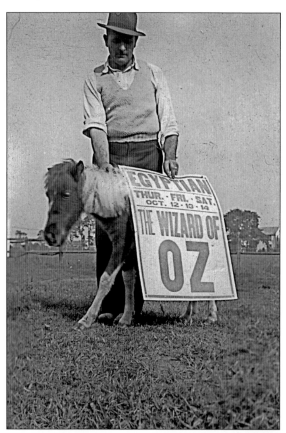

EGYPTIAN THEATER ADVERTISING. Depicted are two examples of a simple technique that was used to advertise theater showings: using anything that moves. In this case, a pony and the Ford pickup truck rented from E. A. Henry's Hardware Store (located just two doors up from the Egyptian Theater) circulated through the neighborhood announcing showings of the *Wizard of Oz* (1939).

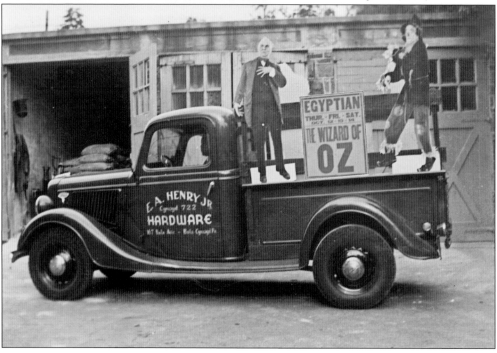

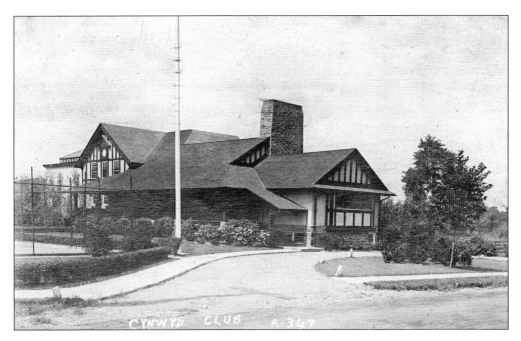

Cynwyd Club, Cynwyd. Founded in 1913, this private sports club was part of the Lower Merion Realty Company's development of the area. One of the attractions for a new home owner to buy and settle in the area was the proximity of a sports club. While it primarily served as a racquet club with tennis and squash courts, it also offered rooms for meetings and banquets. For decades, the club had bowling alleys and employed young men to be "pin-boys" to reset the pins. It remains an esteemed facility and is undergoing a number of expansions and renovations. This is a real black and white photograph with a divided back.

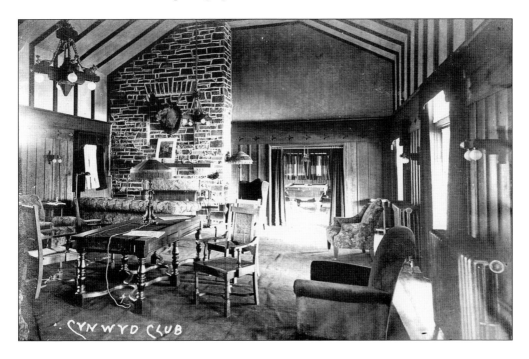

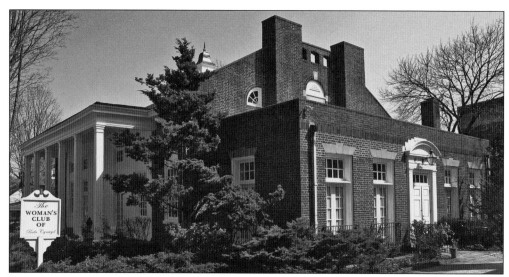

WOMAN'S CLUB OF BALA CYNWYD. According to the 1937 pamphlet, "Your Bala Cynwyd," produced by the Neighborhood Club of Bala Cynwyd, the Woman's Club "was founded 25 years ago for the purpose of 'creating a center for thought and action, for civic betterment, and for the highest and best in literature, music and art.' It has become one of the greatest forces for good in the community, continually initiating and supporting movements for civic and cultural improvement. In its early days, meetings were held at the homes of members, later in the Cynwyd Club, and the Presbyterian Church, until in 1927 the present Club House was erected. This building is used for club functions, both senior and junior, and for Red Cross, Needlework Guild, and Social Service Meetings. It is also a center for many social and community activities."

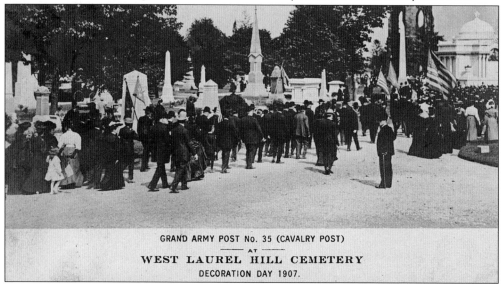

GRAND ARMY POST No. 35 (CAVALRY POST)
AT
WEST LAUREL HILL CEMETERY
DECORATION DAY 1907.

WEST LAUREL HILL CEMETERY, CYNWYD. Established in 1869 as a nondenominational cemetery, West Laurel Hill has long been a landmark in the Philadelphia region. Visiting cemeteries was a popular activity for Victorians, and the location of the region's largest cemetery generated a good deal of weekend and holiday traffic. Today it encompasses 187 acres, including 13 miles of winding roads, an arboretum, and an outdoor sculpture garden. It is listed as a National Register Historic District and remains an active cemetery and park.

BY
PENNSYLVANIA RAILROAD
TO
BARMOUTH STATION

LEAVE

ROAD ST.—7.35–8.17–10.20 A.M.
 12.48–2.05–3.20–4.17 P.M.

WEST PHILA.—7.40–8.22–10.25 A.M.
 12.53–2.10–3.25–4.22 P.M.

2nd ST.—7.46–8.28–10.31 A.M.
 12.59–2.16–3.31–4.28 P.M.

WYNNEFIELD BALA CYNWYD
 BARMOUTH

LEAVE BARMOUTH FOR PHILA.
.36–10.39 A.M. 1.14–3.08–5.02–5.59 P.M.

ON FOOT

MANAYUNK TROLLEY 61
N NINTH ST. AND ON RIDGE AVE.
TO
ENCOYD FOOT BRIDGE 4 SQUARES
EYOND WISSAHICKON CREEK, WALK
VER PENCOYD BRIDGE INTO THE
 CEMETERY

TIME TABLE & ROUTES
TO
WEST LAUREL HILL CEMETERY

HOW and WHEN
Conveyance—Time

DECEMBER 1926

By Automobile
=
Train
=
Trolley & Motor Bus
=
On Foot

Clock Tower at office West Laurel Hill Cemetery

WEST LAUREL HILL CEMETERY. A 1926 booklet outlines five modes of transportation to get to West Laurel Hill Cemetery, including a Pennsylvania Railroad train schedule to and from Barmouth Station. In addition, many passengers disembarked the No. 61 trolley at Manayunk and walked to the grounds via the Pencoyd Bridge. (Courtesy of West Laurel Hill Cemetery.)

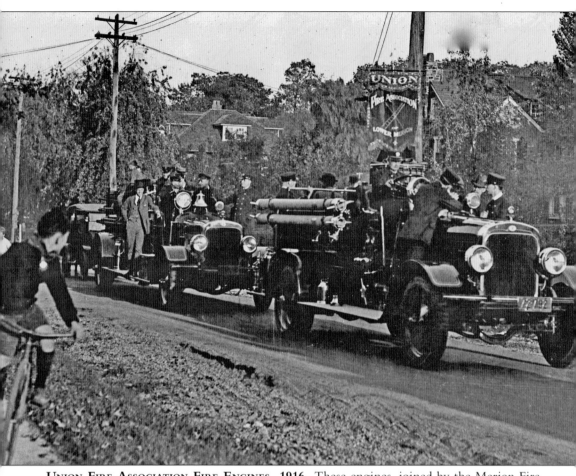

UNION FIRE ASSOCIATION FIRE ENGINES, 1916. These engines, joined by the Merion Fire Company's Autocar, took part of the 1916 Independence Day Parade in Bala Cynwyd.

THE 1916 INDEPENDENCE DAY PARADE. The Neighborhood Club of Bala Cynwyd, the civic association for Bala Cynwyd, was established in 1906 and is the oldest civic association on the Main Line. To this day, the Neighborhood Club continuously works to preserve the residential character of its neighborhood and to protect civic welfare and promote community spirit. Pictured is the first Neighborhood Club's Fourth of July pageant in 1916. Above, Lady Liberty is staged on the steps of the Cynwyd Elementary School. Patriotic themes were acted out in parades, dioramas, community fetes, and historical pageants.

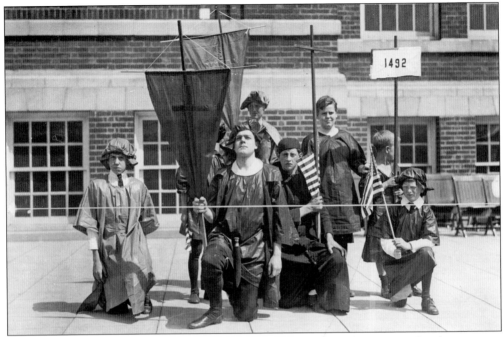

THE 1916 INDEPENDENCE DAY DIORAMAS, CYNWYD SCHOOL. Some popular themes were Columbus discovering America (1492), the arrival of the *Mayflower* (1620), the arrival of William Penn (1682), the signing of the Declaration of Independence (1776), and Betsy Ross making the American flag (1777).

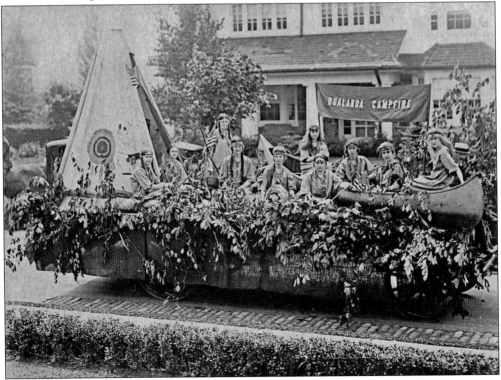

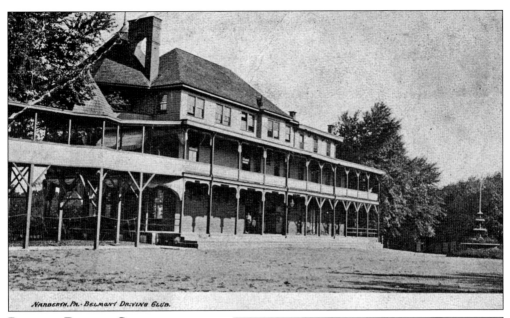

NARBERTH, PA. - BELMONT DRIVING CLUB.

BELMONT DRIVING CLUB AND RACING SCHEDULE, MERION. This recreational facility became operational to the general public just in time for the opening of the 1876 centennial exposition in Philadelphia. The exposition was located in nearby Fairmount Park, only a short train ride to Elm Park (i.e. Narberth). The driving club was located on 72 acres along Meeting House Lane and had a mile-long oval track, along with an additional half-mile track and a clubhouse. It was in active use from 1876 to 1924. In later years, automobile and motorcycle racing supplanted the horse races. In the 1930s, the area was sold and transformed into a model housing development called Merion Park. This real photo postcard was published by the World Post Card Company in Philadelphia.

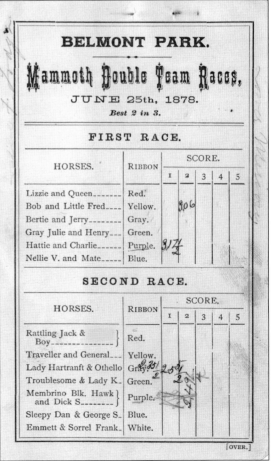

BELMONT PARK.

Mammoth Double Team Races,

JUNE 25th, 1878.

Best 2 in 3.

FIRST RACE.

HORSES.	RIBBON	SCORE.				
		1	2	3	4	5
Lizzie and Queen_____	Red.					
Bob and Little Fred____	Yellow.		306			
Bertie and Jerry_____	Gray.					
Gray Julie and Henry___	Green.					
Hattie and Charlie_____	Purple.	317 1/2				
Nellie V. and Mate_____	Blue.					

SECOND RACE.

HORSES.	RIBBON	SCORE.				
		1	2	3	4	5
Rattling Jack & Boy_____	Red.					
Traveller and General___	Yellow.					
Lady Hartranft & Othello	Gray.	2 35/2	255 1/4			
Troublesome & Lady K_	Green.		29 1/4			
Membrino Blk. Hawk and Dick S_____	Purple.		5			
Sleepy Dan & George S_	Blue.					
Emmett & Sorrel Frank_	White.					

[OVER.]

113

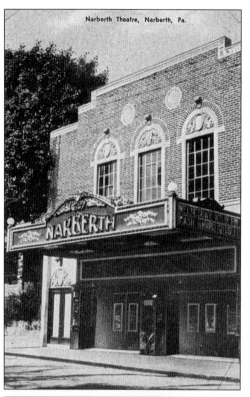

Narberth Theatre, Narberth, Pa.

NARBERTH THEATER. The Narberth Theater opened on November 1, 1927, with *Loves of Carmen*. Architect Jacob Ethan Fieldstein used New York City's Roxy Theatre as inspiration. Evening performances were 35¢ for adults and 25¢ for children; Matinee prices were 25¢ for adults and 15¢ for children. The auditorium originally had 856 seats, a Wurlitzer organ (long since gone), a stage, and dressing rooms for vaudeville performers. In 2004, "the Narberth" was remodeled. The auditorium's decorative plaster was hidden behind fake walls and ceilings but not destroyed, thus preserved, if not appreciated.

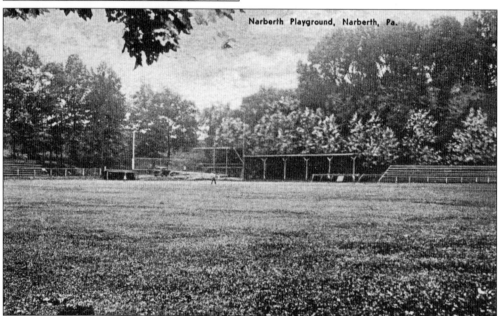

Narberth Playground, Narberth, Pa.

NARBERTH PLAYGROUND. Since its construction in the 1920s, the playground in Narberth has served as the main recreational venue in the borough. This quaint village park contains a baseball field; two full-size, lighted basketball courts; several tennis courts; a building containing lockers and restrooms; and a veterans' memorial. But the all-day July 4 events—including the ever-popular fireworks display—are what most Main Liners associate with Narberth's playground.

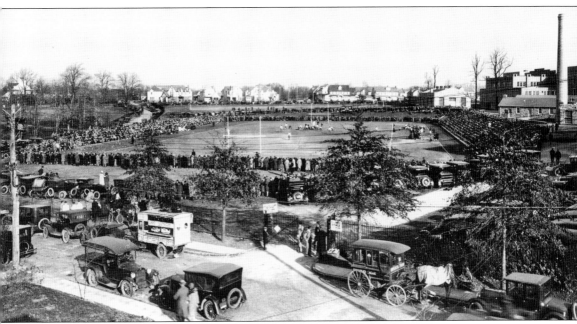

LOWER MERION/RADNOR FOOTBALL GAME 1925. Pennypacker Athletic Field was named for a beloved principal of Lower Merion Senior High School, Charles B. Pennypacker. It was Lower Merion High School's first athletic field and was between Owen Road (houses in the rear) and School House Lane (in the foreground). The football rivalry between Lower Merion and Radnor is reported to be one of the oldest continuing public high school competitions. The white, square, truck body on the lower left is the omnipresent ice cream vendor.

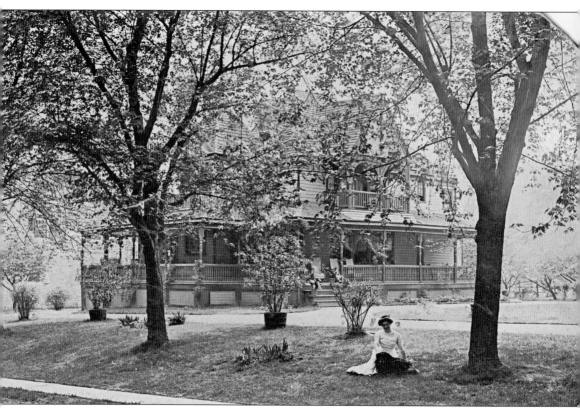

PHILADELPHIA FIELD AND CYCLE CLUB, ARDMORE, 1911. The Philadelphia Cycle and Field Club received a corporate charter in November 1889 and, by March 1890, had acquired this gorgeous, Queen Anne–style house on Lancaster Pike at the corner of Church Road in Ardmore. Eager to display their new home, the club celebrated a gala open house on February 22 of that year. Bicycle clubs thrived in Philadelphia and surrounding communities during the 1890s. However, interest in cycling among adults waned during the early years of the 20th century due to the advent of automobiles. In 1904, the Ardmore club and its furnishings were sold to pay outstanding mortgages and taxes.

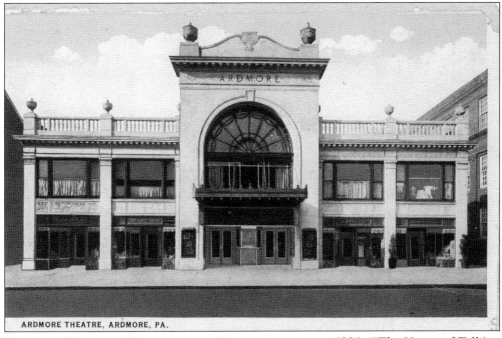

ARDMORE THEATRE, ARDMORE, PA.

ARDMORE THEATER, EXTERIOR AND INTERIOR, AROUND 1926. "The House of Talkies, Vitaphone and Movietone – Playing All the Choice Photoplays Exactly as Shown in Town," announced advertisements for the theater. Talkies were so popular that most villages had one or two movie theaters; Ardmore was no exception. The Ardmore Theater opened in 1926 and remained a popular movie house for over seven decades until it was closed in 2000. While the local historical preservation community tried to save it, the theater was, nonetheless, gutted and reopened as a fitness center in 2002.

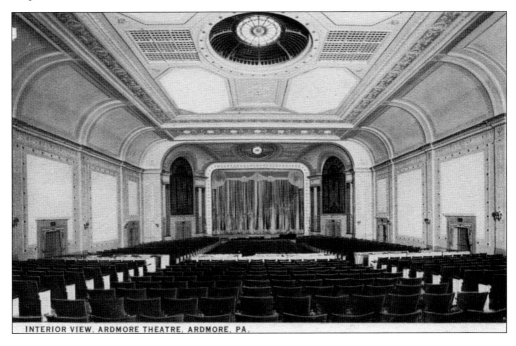

INTERIOR VIEW, ARDMORE THEATRE, ARDMORE, PA.

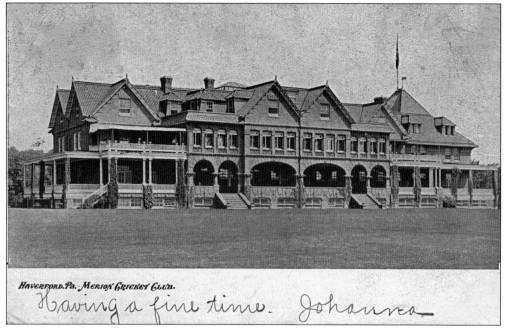

Having a fine time. Johanna

MERION CRICKET CLUB, HAVERFORD. Since moving from Ardmore to Haverford in 1892, this private club has provided lawn tennis, bowling, golf, cricket, soccer, squash, field hockey, and badminton. Furness, Evans, and Company was the architect for the building, which is listed on the National Register of Historic Places as a national landmark.

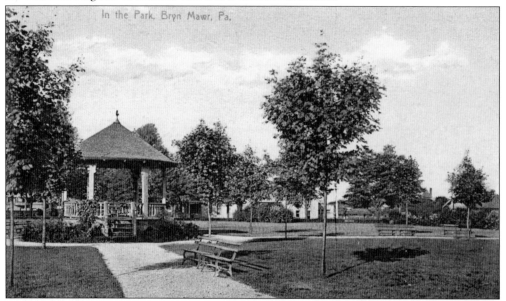

THE PARK, BRYN MAWR. Bryn Mawr was an important station stop along the Pennsylvania Railroad. Directly across the street from the depot was an attractive park with World War I memorials. This once-open space is currently used as a municipal parking lot for rail commuters and shoppers. The township, with feedback from local businesses and residents, has completed a master plan for Bryn Mawr, which includes a proposal to remove the parking lot and reinstall a pocket park with a similar footprint. This is a colorized card with a divided back.

Eight

RESIDENCES, NEIGHBORHOODS, AND STREETSCAPES

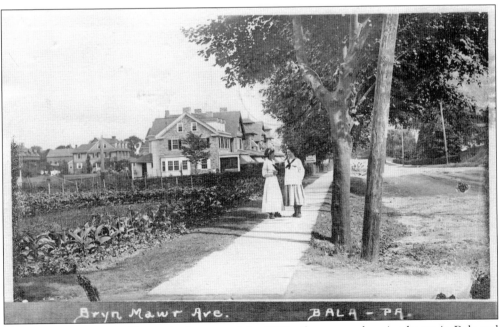

BRYN MAWR AVENUE, BALA. At the start of the 1900s, there was a housing boom in Bala and Cynwyd. Pictured are some of the new single-family homes as they appeared in 1902. The view is along Bryn Mawr Avenue, near Heckamore Road, looking towards City Line Avenue. This emerging suburban community, located next to Philadelphia, was noted for its beautifully landscaped yards, tree-lined streets, and housing of stone construction.

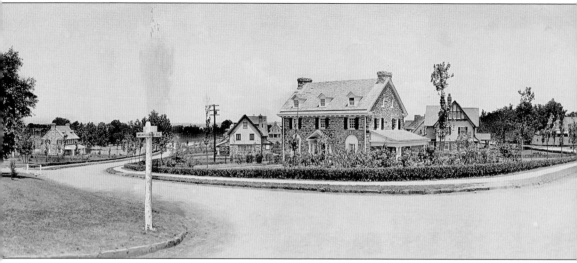

LOWER MERION REALTY COMPANY AROUND 1910. Titled "A General View of the Property as Seen from Cynwyd Station," this image is part of a promotional booklet, complete with floor plans for the properties developed by the Lower Merion Realty Company. The members of the Roberts family of Pencoyd were the major stakeholders in the company. Their idea was to build

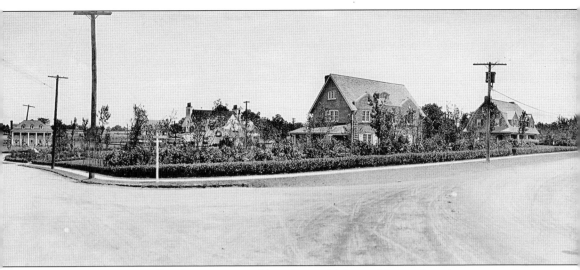

attractive houses and offer them at reasonable prices, which would appeal to the conservative man of moderate means desiring a modern, substantial home in the suburbs. With easy access to Philadelphia, these home owners had all the conveniences of the city. This commuter population was able to walk to and from their closest train station—in this case, Cynwyd Station.

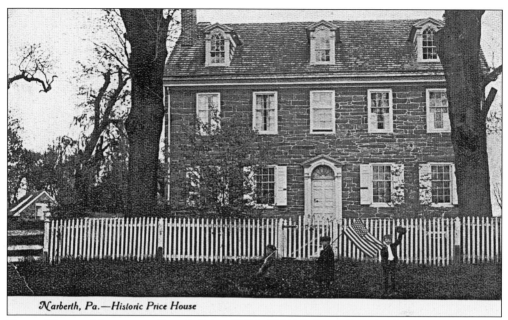

Narberth, Pa.—Historic Price House

PRICE HOUSE, NARBERTH. Joseph Price (1753–1828) belonged to the fourth generation of the Price family to live in Lower Merion. His great grandfather Edward ap Rees ("ap" being Welsh for "son of") arrived in the area from Wales in 1682. He purchased over 200 acres from William Penn. By 1780, the Price holdings included what are now Narberth and a large part of Wynnewood. Joseph Price was the great Renaissance man of Lower Merion. As the historical marker outside of the house on Montgomery Avenue attests: "Quaker Farmer, Innkeeper, Undertaker, Militiaman, Diarist, Saw Mill Operator, Milestone Installer, Carpenter, Turnpike Supervisor, Patriot, Concerned Citizen."

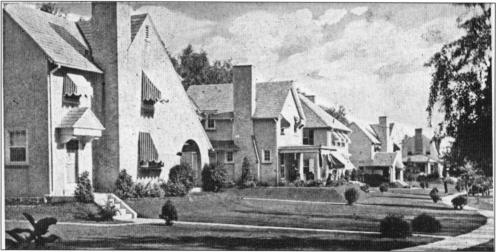

NARBROOK PARK PROMOTIONAL POSTCARD AROUND 1920. Advertised as a model community, the 35-unit, 14-acre housing development was spearheaded by the Narberth Civic Association. Instigating such a project was, and is, quite uncommon for a suburban civic association. As befits a community project, Narberth citizens were engaged in the design and planning process. The commons of the development is still maintained by the Narbrook Park Association—having to look after its own road repair, plowing, and tree maintenance.

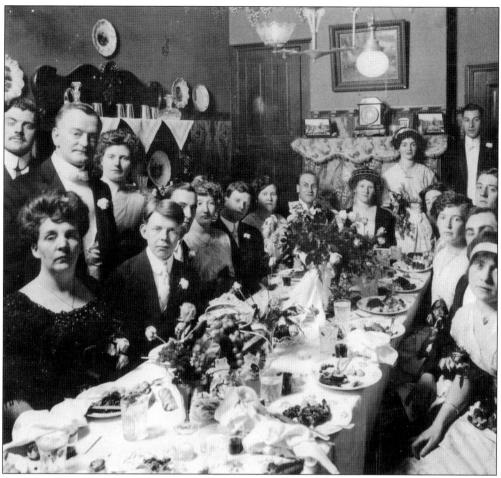

The Servants Dinner, Penshurst Farm, Penn Valley. Running a sprawling estate, such as Penshurst Farm, required dozens of servants. Indeed, the vast majority of the workforce in Lower Merion was dedicated to providing supportive services to the upper class—yet they are rarely represented in the memorabilia that survives today. While historical archives are full of photographs of the interiors and exteriors of Main Line castles, photographs of servants were rarely taken—inside help was trained to be invisible until called upon and silent until spoken to. A hierarchy was strictly adhered to by those individuals "above the stairs," and there was a similar hierarchy employed by the servants who were "below the stairs." Servants were given similar rank and privileges based on whom they served, but reduced in scale. For example, on special occasions, such as the servants' dinner, the junior staff was expected to wait on the senior household staff.

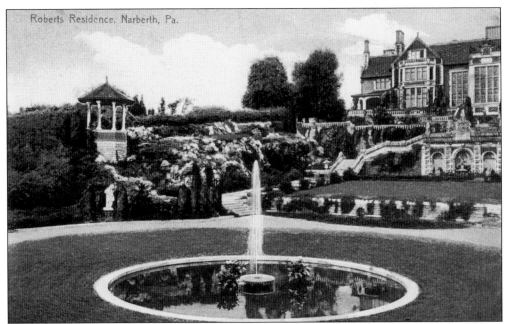

Roberts Residence, Narberth, Pa.

WORLD'S CHAMPION TWO-YEAR-OLD, PENSHURST FARM, PENN VALLEY. Percival Roberts's Penshurst Farm was a magnificent 539-acre estate with a 75-room main house. It was much more than a country house—it was, indeed, a so-called "gentleman's farm" that was self-sufficient, with dairy barns, on-staff veterinarians, and dozens of farmhands and landscapers to maintain the property. This postcard was published by the Roberts family to showcase members of their award-winning herd. Due to a disagreement with the township, the estate was dismantled and sold off in the 1940s. By the 1960s, much of the land had been subdivided and developed into private residences, with a portion used for the Welsh Valley Middle School.

Castlemains Nancy 4th, 28520, World's Champion Two-year-old, Penshurst Farm Narberth Pa.

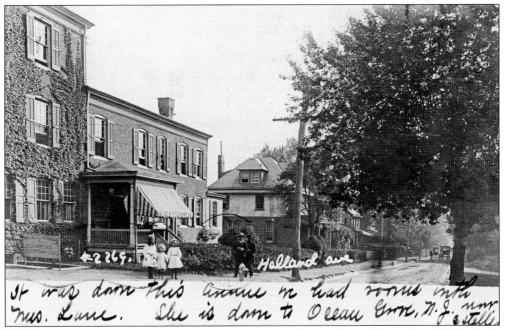

It was down this avenue we had rooms with Mrs. Lane. She is down to Ocean Grove, N.J. now Estelle

HOLLAND AVENUE, ARDMORE. Holland Avenue is on the periphery of the industrial district in Ardmore. These twin homes were just one block from The Autocar Company and the Merion and Radnor Gas and Electric Company.

LLANFAIR ROAD, ARDMORE. In 1910, the 123-acre estate of Louis Wister was sold and subdivided to build the Lower Merion Senior High School and a neighborhood of single-family homes. This attractive community, on the north side of the PRR tracks, was within walking distance from downtown Ardmore. The personal message on the back reads: "May 7th, 1916. Dear Friend, This sure is some town, they even got tin cans here [slang for cars], as you will see on the other side to the right. I have seen some of my friends at the zoo last Sunday. Your Friend, Somebody."

ST. PAUL'S ROAD, ARDMORE. At the start of the century, Ardmore was expanding its housing stock on the south side of the PRR tracks. One of the new streets created was St. Paul's, which acquired its name from the nearby church Evangelical Lutheran Congregation of Saint Paul's. These single-family homes were conveniently located a few short blocks from the center of the Ardmore business district.

HARRITON HOUSE, BRYN MAWR. This stone dwelling was part of a 700-acre plantation owned by Welsh Quaker Rowland Ellis who named it Bryn Mawr, meaning "high hill." Later it was home to Charles Thomson, secretary to the Continental Congress and the Confederation Congress. Today it is owned by the township and administered privately by the Harriton Association, which operates as a cultural and educational center. It is registered on the National Register of Historic Places.

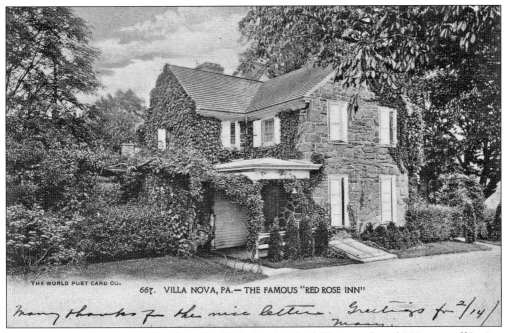

667. VILLA NOVA, PA.— THE FAMOUS "RED ROSE INN"

Many thanks for the nice letter. Greetings from 2/14/ many.

RED ROSE INN, VILLANOVA. In the early 1900s, Frederick Phillips purchased 800 acres off Spring Mill Road with several simple 18th-century farmhouses. He named the property Stoke Pogis (sic), after William Penn's family home in England, and remodeled one farmhouse in the style of a colonial inn, calling it the Red Rose. Here he built an arts colony, that is, a community of artists and craftsmen who shared common tastes. The most notable residents were the "Red Rose Girls"—Jessie W. Smith, Elizabeth S. Green, and Violet Oakley.

EGBERT'S MILL, GLADWYNE. Egbert's Mill, on Rose Glen Road in Gladwyne, was most likely constructed between 1835 and 1845 by George and Elizabeth Potts. It was later owned by Hamilton Egbert, who manufactured wicks for candles. Today the mill has been converted into a private residence but, aside from a garage addition, remains largely unchanged. The building is listed as a Class 1 Historic Resource in the Mill Creek National Historic District. To further protect this resource, the owner signed a facade easement agreement. This property has multiple layers of protection and is a good example of responsible stewardship of our local heritage.

www.arcadiapublishing.com

Discover books about the town where you grew up, the cities where your friends and families live, the town where your parents met, or even that retirement spot you've been dreaming about. Our Web site provides history lovers with exclusive deals, advanced notification about new titles, e-mail alerts of author events, and much more.

MADE IN THE

Arcadia Publishing, the leading local history publisher in the United States, is committed to making history accessible and meaningful through publishing books that celebrate and preserve the heritage of America's people and places. Consistent with our mission to preserve history on a local level, this book was printed in South Carolina on American-made paper and manufactured entirely in the United States.

This book carries the accredited Forest Stewardship Council (FSC) label and is printed on 100 percent FSC-certified paper. Products carrying the FSC label are independently certified to assure consumers that they come from forests that are managed to meet the social, economic, and ecological needs of present and future generations.

FSC
Mixed Sources
Product group from well-managed forests and other controlled sources

Cert no. SW-COC-001530
www.fsc.org
© 1996 Forest Stewardship Council

Find Your Place in History.